To: ..

From: ..

"Take the very hardest thing in your life—the place of difficulty, outward or inward, and expect God to triumph gloriously in that very spot. Just there He can bring your soul into blossom."

Lilias Trotter

from Parables of the Cross

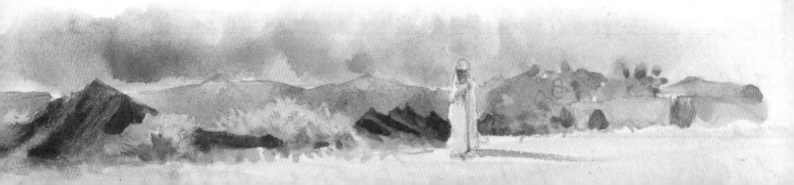

All of Lilias Trotter's journals, diaries, sketchbooks, and artwork, unless otherwise noted, are copyright © 1998 by Arab World Ministries. Used courtesy of Arab World Ministries archives.

Discovery House Publishers is affiliated with RBC Ministries, Grand Rapids, Michigan.

Discovery House books are distributed to the trade exclusively by Barbour Publishing, Inc., Uhrichsville, Ohio.

Scripture quotations are from the New International Version® NIV.® Copyright © 1973, 1978, 1984 by International Bible Society. Used by permission of Zondervan. All rights reserved.

Scripture quotations in Lilias Trotter's diary and journal excerpts are from the Authorized Version (King James Version).

Cover and interior design by Veldheer Creative Services.

Library of Congress Cataloging-in-Publication Data

A blossom in the desert : reflections of faith in the art and writings of Lilias Trotter / compiled and edited
 by Miriam Huffman Rockness.

 p. cm.

 ISBN-13: 978-1-57293-256-2

 1. Trotter, I. Lilias (Isabella Lilias), 1853-1928. 2. Missionaries–Algeria–Religious life. 3. Missionaries–England–Religious life. 4. Artists–England–Religious life. I. Rockness, Miriam Huffman, 1944–
BV3587.T76B56 2007 266.0092–dc22 2007026669

07 08 09 10 / P / 10 9 8 7 6 5 4 3 2 1

Printed in Belgium

Reflections of Faith in the Art and Writings of Lilias Trotter

A Blossom in the Desert

Compiled and Edited by Miriam Huffman Rockness

Discovery House Publishers
Books, music, and videos that feed the soul with the Word of God
Box 3566 Grand Rapids, MI 49501

This book is lovingly dedicated to

Norm and Bonnie Camp

who, like Lilias, devoted their lives to bringing the light and life and love of Jesus Christ
to the Arab people, and whose prayers, interest, guidance, and encouragement were a continual
source of instruction and inspiration throughout this journey of faith and discovery.

CONTENTS

(Continued)

CONTENTS

PREFACE

"Who is Lilias Trotter?" is the predictable response to my two-decade fascination with this virtually unknown woman. The answer to that question is most frequently followed by another question: "How did you discover her?" The first question is answered briefly in the Introduction to this book and, more comprehensively, in her biography, A Passion for the Impossible: The Life of Lilias Trotter. The second question I generally counter with my own: "Do you want the long version or the short version?" For our purposes here, I will relate the "short version." I am eager for you to enter into the pages of A Blossom in the Desert and discover her for yourself.

My introduction to Lilias Trotter was the result of a fortuitous encounter with two elderly sisters, Jane and Betty Barbour, over two decades ago. They were wintering in Lake Wales, Florida, due to a fire at their usual seasonal site. Visiting the local Presbyterian church, of which my husband is minister, they noted his surname—the same as a woman who had befriended their eldest sister, many years before, while she was teaching English in Singapore. The discovery that their sister's friend was my husband's mother led to a dinner engagement where, for the first time, I heard the name Lilias Trotter—a woman the sisters knew only through the beautifully illustrated devotional books she began publishing in the 1890s.

I listened enthralled as they talked about this well-born daughter of a distinguished Victorian family whose heart led

her into volunteer work in London while her artistic talent led to a friendship with John Ruskin, artist, critic, social philosopher, and a towering figure in Victorian England. They related more of Lilias's remarkable life: her involvement with the fledgling YWCA at Welbeck Street Institute in London and her eventual call to Algeria, where she served the Arab people for the remaining forty years of her life. Their pressing concern, however, was their collection of her once-popular devotional books. They were about to dissolve their library and feared that no one would appreciate Lilias's work as they did.

Several months later, to my complete surprise, a package arrived containing a cameo biography with the title, Lilias Trotter of Algiers, embossed in gold on the white cover, and a leaflet with a delicate cover sketch of a fir wood printed on ivory stock and bound by a slender cord: Focussed: A Story & A Song—a tiny devotional classic of rare beauty and depth. Over

I was determined to track down other out-of-print works alluded to in writings about her—and I longed to know even more about the woman behind the books.

the next several years, one by one, without announcement, other volumes appeared in my mailbox, until perhaps the loveliest arrived—an Algerian sketchbook, Between the Desert & the Sea—with a note from our friends informing me that this was the final volume of their collection.

By then I was totally besotted by Lilias. I was determined to track down other out-of-print works alluded to in writings about her—and I longed to know even more about the woman

This discovery convinced me that Lilias's extraordinary written and artistic legacy should not be forgotten.

behind the books. A tantalizing reference by an early biographer to "thirty little diary volumes" seemed to hold the key to my questions. But where were they located? And what had become of the Algiers Mission Band, the organization of some thirty men and women who eventually joined Lilias in North Africa? Unwittingly, I became a detective, following, through phone or mail, any clue that might help me discover the fate of Lilias's ministry—and those elusive diaries! My search took me on a circuitous path which led, after five years, to Loughborough, England, to the UK headquarters of Arab World Ministries, a step-grandchild of Lilias's mission band. Here, at last, I discovered her archives: a rich reservoir of books and leaflets—and most compellingly, her diaries and journals, illuminated by exquisite watercolors and strong sketches!

This discovery convinced me that Lilias's extraordinary written and artistic legacy should not be forgotten. I began to see if I could arrange to have her books reissued and was told that the only way they had a chance of being marketable was if her reputation were revived. A biography had to be written. With the encouragement of Marj Mead and Lyle Dorset at the Wade Center in Wheaton, Illinois, it was determined that I was the one to write it and that Harold Shaw Publishers, under the North Wind Books Imprint, would publish it.*

*A Passion for the Impossible is presently in print and available from Discovery House Publishers.

In 1995 I returned to England, this time to research for the writing of her biography. With a full month stretching before me, I immersed myself in Lilias's astonishingly beautiful diaries and travel journals, where she documented in words and watercolors the seasons of her life in Algeria. Of course there was more sleuthing to be done. Map in hand, I roamed London's West End searching out her early homes and haunts. Curator in tow, I hunted down the paintings Ruskin had given to the Ashmolean Museum in Oxford. After my return home, over a period of time, with much trans-Atlantic communication to Trotter family members and friends, Ruskin scholars, and the archivist for YWCA of Great Britain, piece by piece, I gathered more and more information about her life.

In the summer of 2000, several years after the publication of the biography, I had the privilege of presenting a paper, " 'an old porcelain maker; a dainty bit of clay': the Ruskin/Trotter Friendship," at the International Symposium sponsored by The Ruskin Programme. A weekend at Brantwood, Ruskin's home in the Lake District, where Lilias spent many a fortnight at the home of her mentor, was part of the event celebrating the centennial of Ruskin's death. The response of scholars fascinated with this "missing piece" of the Ruskin saga as well as with Lilias's art—validating the influence of her mentor—and the viewing of additional paintings and correspondence of Lilias at The Ruskin Museum at Lancaster University, heightened my desire to reclaim

A Blossom in the Desert . . . is the end of a long journey of discovery for me and, I anticipate, the beginning of the same for you.

from the past the paintings of this talented artist. A visit to Robert Egerton, Lilias's grandnephew, in Surrey, further quickened this desire, when he showed me, among other treasures, the very sketchbook that Lilias had produced under Ruskin's guidance in Venice. I am immeasurably grateful to him for generously making available to me that important sketchbook as well as two of Lilias's significant travel journals.

This dream, inspired by my first glimpse of her paintings and spurred by events following, evolved into a sketchbook pairing these paintings (from images reproduced by the Canon 700 copier while in England) with writings excerpted from the diaries, journals, and out-of-print books. While several publishers initiated interest in this venture, the cost and the complexity of such an undertaking thwarted publication. Three factors brought the dream into reality: a generous gift from Larry and Anita Maxwell to underwrite the photographing of the original 1000-plus images as well as the color printing for this book; the vision of Discovery House Publishers, under the superb direction of publisher Carol Holquist and editor Judith Markham; and the continued co-operation and able assistance of Alasdair McLaren at Arab World Ministries.

A Blossom in the Desert: Reflections of Faith in the Art and Writings of Lilias Trotter is a dream come true. It is the end of a long journey of discovery for me and, I anticipate, the beginning of the same for you.

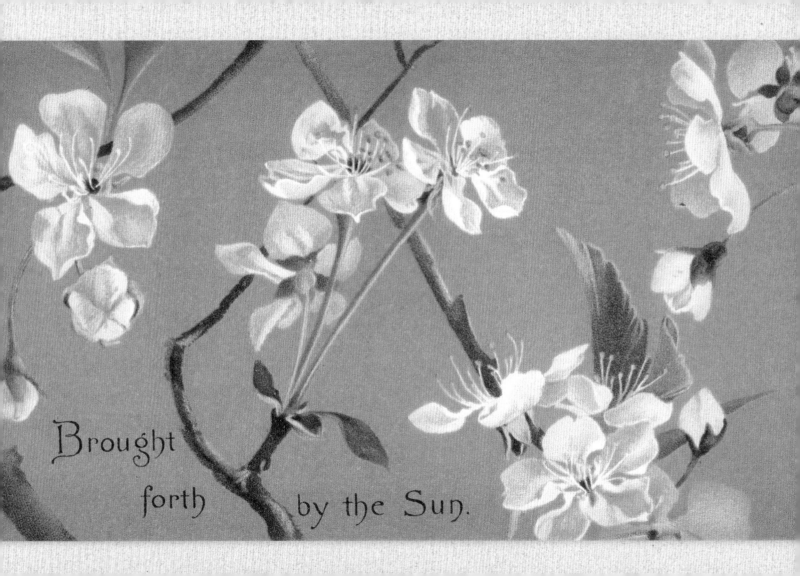

Brought

forth by the Sun.

INTRODUCTION

John Ruskin, in his 1883 Oxford lecture "The Art of England," tells of meeting a young woman, Lilias Trotter, who challenged his prejudice about artists. "For a long time I used to say, in all my elementary books, that except in a graceful and minor way, women could not draw or paint. I'm beginning to bow myself to the much more delightful conviction that no one else can." Exhibiting a half-dozen framed pages from her Norwegian sketchbook for his students to copy, Ruskin advised, "You will in examining them, beyond all telling, feel that they are exactly what we should like to be able to do, and in the plainest and frankest manner shew us how to do it—more modestly speaking, how, if heaven help us, it can be done."

Eight decades later, Sir Kenneth Clark, in the introduction to his book Ruskin Today, mentions Ruskin's "ecstasy" over the drawings of Lilias Trotter, noting that she is no longer remembered—and thereby implying that she was not of artistic consequence. Today, over a century after Ruskin's historic lecture, the exhibition paintings, along with thirty-four other leaves from Lilias's sketchbook, are buried in the Print Room of the Ashmolean Museum in Oxford, England, filed in the Long Cabinet of the Ruskin Art Collection—a hidden testament to potential recognized, promise unrealized.

Who was this Lilias Trotter? She was born Isabella Lilias Trotter on 14 July 1853 into the large and wealthy family of Alexander and Isabella Trotter. She grew up in the privileged surroundings of London's West End during the Golden Age of Victoria, experiencing the private tutelage of governesses at home and the stimulation of Continental travel by horse-drawn carriage during the summer months.

Her spiritual receptivity, early observed by family and friends, was quickened in her early twenties during the deeper-life conferences held at Broadlands, Oxford, and Brighton,

which developed into the permanent Keswick Conferences, a worldwide institution vital to this day. Hungry for nourishment that would draw her closer to her heavenly Father, she found her understanding of Christian faith and practice clarified and solidified, and "the rudder of her will was set" toward God's purposes.

Lilias's freshly kindled faith was stretched and applied to volunteer mission work with the then-fledgling YWCA at Welbeck Street Institute, a hostel for London working girls. Her heart also reached out to women of a more questionable occupation—the prostitutes of Victoria Station—whom she brought to the institute for training in "honorable employment." Her heart was moved with compassion for these "lost sheep," and along with offering them training in an employable skill, she introduced them to the Good Shepherd. Her part-time work at

Lilias Trotter, age 10

Lilias Trotter, age 27

Welbeck Street Institute eventually evolved into the full-time role of "honorable secretary." As part of this work, she helped open London's first affordable public restaurant for women, so that they would not be forced to eat bag lunches on city sidewalks.

Parallel to her zeal for service was a passion for art born of an innate sensitivity to beauty, matched by an exceptional God-given artistic talent. It was this talent that caught the eye and interest of John Ruskin,

the foremost art critic of the day and a monumental and influential figure.

The fortuitous meeting of John Ruskin and Lilias was initiated by her mother during their residency at the Grand Hotel in Venice. Upon learning that the great master was residing at the same hotel, Mrs. Trotter sent Ruskin some of Lilias's watercolors, accompanied by this note:

"Mrs. Alex Trotter has the pleasure of sending Professor Ruskin her daughter's water-colours. Mrs. Trotter is quite prepared to hear that he does not approve of them—she has drawn from childhood and has had very little teaching. But if Mrs. Trotter could have Mr. Ruskin's opinion it would be most valuable."

Ruskin's response is immortalized in his "The Art of England" lecture: "On my somewhat sulky permission a few were sent, in which I saw there was extremely right minded

Lilias Trotter viewed the world as Ruskin did, with "heartsight as deep as eyesight."

and careful work." And thus began the unique friendship of the fifty-seven-year-old John Ruskin—artist, critic, social philosopher—and twenty-three-year-old Lilias. Ruskin, author of the The Stones of Venice, the definitive artistic and architectural history of the city, took her under his wing, squiring her about on sketching expeditions and inviting her to study with him upon her return to England. Quickly he became convinced that she had a rare artistic talent, which, if cultivated, would make her one of England's "greatest living artists."

It is impossible to overestimate the effect of this distinguished mentor and friend on the art and life of Lilias. She viewed the world as Ruskin did, with "heartsight as deep as eyesight," to borrow a phrase he used to describe his hero, J. M. W. Turner.

She adored nature and was moved to tears, as was he, upon first sighting the Alps. Ruskin believed that without a knowledge of drawing, one could not fully appreciate nature: "I would rather teach drawing that my pupils may learn to love Nature, than teach the looking of Nature that they may learn to draw." He told his students, "Go to Nature, in singleness of heart." Techniques, he believed, must be acquired hand in hand with the skill of "learning to look."

If Ruskin was the consummate teacher, Lilias was the ideal student. Ruskin said in his lecture, "She seemed to learn everything the instant she was shown it, and ever so much more than she was taught." To Lilias he wrote, "I pause to think how—anyhow—I can convince you of the marvelous gift that is in you." Just as Ruskin had championed such artists as

John Millais and Dante Gabriel Rossetti, he was prepared to advance Lilias's career in both the development of her art and the promotion of the same.

As Lilias's immersion in painting deepened, so did her commitment to her spiritual calling. But Ruskin complained of the toll her ministry was taking on their friendship and expressed concern that her work in London was affecting the character of her art.

It was with this in mind that Ruskin brought Lilias to Brantwood, his home in the Lake District, in May 1879, three years after their initial meeting, to put before her the brilliant future he maintained would undoubtedly be hers if she were to give herself fully to the development of her art. Dazzled, Lilias wrote to a friend that Ruskin believed "she would be the greatest living painter and do things that would be Immortal." With his talent as a teacher and his power as cultural leader, Ruskin could launch her career single-handedly. But the offer came with a caveat. To become "Immortal" she would have to "give herself up to art."

This challenge shook Lilias to the core. "At first," she wrote, "I could only rush about in the woods all in a dream, and it was like a dream for the first day or two. Since then an almost constant state of suffocation half intoxication so that I can hardly eat or sleep except by trusting the Lord about it." After days of agonizing deliberation, she saw she could not devote herself to both art and ministry. She wrote, "I see clear as daylight now, I cannot give myself to painting in the way he means and continue to 'seek first the Kingdom of God and His Righteousness.' "

Many of her friends and family members were shocked and disappointed by her decision. And, indeed, anyone venturing into the Ashmolean Museum will find it heart-wrenching.

There, in frame after frame, are works by Ruskin's disciples—Millais, Rossetti, Holman Hunt, Ford Maddox Brown—whereas Lilias's works, clearly their equal in artistry if not complexity, are filed away, viewable only by request.

No one knew better than Lilias how her renunciation of Ruskin's offer would impact her life. Many years later, a life-long friend recounted that "the ache of desire was with her to the end, not so much on the many days when she did no drawing, as on the days when she took up her brush . . . conscious of the pain of the artist who takes up an unpracticed tool and knows full well to what beauty he might bend it if he could but give to it his strength and life."

Lilias returned to London and threw all her energies into her city work, integrating all her past teaching, training, and life experience into a vocation of caring. She continued her friendship with Ruskin as well as her art, but now with "a grand

"We can do without anything while we have God."

independence of soul," which she would later describe as "The liberty of those who have nothing to lose because they have nothing to keep. We can do without anything while we have God."

Then, in May of 1887, in a meeting about the challenge of foreign missions, she listened to a message about those in North Africa who had never heard the name of Christ. She felt the call of God on her life to bring the message of Jesus Christ to the people of Algeria.

The rest happened in an astonishingly short period of time. She applied to the North African Mission and was turned down for health reasons. Then, with her own resources, she set about to go to Algeria to work alongside, but not officially connected with, the same mission. The following March, at the age of

Lilias Trotter, age 35

thirty-five, she set off for North Africa with two friends (one of which left after the first year) to Algiers, where she knew no one nor knew a word of Arabic. She eventually took up residency in the Arab section of the Casbah, the ancient fortified city in Algiers, with its steep, narrow streets crowded with people and warren-like shops.

Over the next four decades, from her base of Algiers, Lilias set up stations along the coast of North Africa and deeper south into the Sahara desert, scouting, on camel, areas never before

She spent the rest of her life bringing the light and life and love of Jesus to the Arab people of North Africa.

visited by a European woman. In sum, she spent the rest of her life bringing the light and life and love of Jesus to the Arab people of North Africa.

At the time of her death in 1928, Lilias had established thirteen mission stations and had over thirty workers, under the name Algiers Mission Band, united in her vision to bring "the light of the knowledge of God, in the face of Christ" to the people of this land, from the cloistered world of Arab womanhood to the Sufi mystics in the desert southlands. During her forty years in North Africa, she pioneered means, methods, and materials

to reach the Arab people, which, in retrospect, are considered to have been a hundred years ahead of her time. She wrote, as well, a body of English devotional literature, most notably Parables of the Cross and Parables of the Christ-life.

Lilias's story is detailed in the biography A Passion for the Impossible: The Life of Lilias Trotter. Her soul is revealed through writings and watercolors that document the inner as well as outward events of her life. Through the years she remained faithful to Ruskin's artistic vision. With her pocket sketchbook and her keen eye she lived the credo he outlined in Modern Painters: "The greatest thing a human soul ever does in this world is to see something, and tell what it saw in a plain way. Hundreds of people can talk for one who can think, but thousands can think for one who can see."

Within months of her arrival in Algeria, Lilias captured in a pocket sketchbook images painted in a glowing range of

Lilias among her Arabs at Tozeur, 1923

colors that would have delighted the color-loving Ruskin: sunrise in golden shades of coral, a bit of blue bay, white-washed houses stacked against hills or nestled within valleys, exotic and common plants and flowers, nationals in robes and headdress. Years later she would exult: "Oh, how good it is that I have been sent here to such beauty!"

Lilias's early journals and letters (1888–1898), followed by thirty compact leather-bound page-a-day diaries (1899–1928),

Throughout her life [Lilias] sought out a "place of quiet"… to listen to God's voice through Scripture and prayer.

supplemented by travel journals, were studies in both beauty and economy of space. Day by day, decade upon decade, through the seasons of her life, Lilias "looked" with "heartsight as well as eyesight," recording in watercolors and words her observations filtered through her heavenly vision: God working out His purposes on a land and in a people. From these records, illuminated by exquisite watercolors and strong sketches—a museum in miniature—emerges a country, intimate and varied, and a people "bright and living."

Ultimately, and most profoundly, emerges a spiritual reality

from her eyes of faith: a vision of the invisible. Francis Bacon wrote: "God has two textbooks—Scripture and Creation—we would do well to listen to both." Lilias "listened" to both. In the early hours of each day she studied Scripture and texts from her little daily devotional volume, Daily Light, to hear God's voice. One of her earliest letters states: "I have found a corner in the Fortification Woods, only five minutes from the house, where one is quite out of sight, and I go there every morning with my Bible from 7:15 till 8:30—it is so delicious on these hot spring mornings, and God rests one through it for the whole day, and speaks so through all living things. Day after day something comes afresh." Throughout her life she sought out a "place of quiet"—a rooftop refuge, a desert palm garden, a Swiss forest of firwood, an Arab prayer room—to listen to God's voice through Scripture and prayer.

And she read God's work, seeing lessons in their design and

Lilias's diaries and watercolors

processes, that revealed to her the Creator, nourishing her beauty-loving spirit as well as her God-loving soul. Her diaries are filled with paintings of lessons learned from the natural world, and her language is laced with such expressions as "The daisies have been talking again," "The word of the Lord came in a dandelion," "A bee comforted me this morning," "The martins have been reading me a faith lesson," "The milky looking glacier torrent spoke with God's voice," "The snow is speaking."

Stamped on every page of her diaries and journals is a woman fully immersed in the practical realities of everyday living, even as she is totally engaged in assimilating these realities through an eternal perspective. It is from the tension of these two realities, the seen and the unseen, that hard spiritual truths are hammered out which later appear in her English devotional books and leaflets, elegant and reasoned, and in her Arabic story parables and booklets, sensitively illustrated to satisfy the color-loving Eastern mind and eye.

It is from these many sources that the writings and watercolors of A Blossom in the Desert have been culled—some paired as she intended, others matched for resonance of word with image—and organized under the great unifying themes of her life: Light and Life and Love. These themes are

further developed under topics of vital spiritual significance through Lilias's eyes of faith that continually integrated the visible world with the verities of the unseen.

In her introduction to Between the Desert and the Sea, her love story of Algeria, Lilias invites the reader to "come and look . . . The colour pages and letter press are with one and the same intent—to make you see." Echoing her mentor Ruskin, she concludes, "Many things begin with seeing in this world of ours."

Lilias painted and wrote in obscurity with no concern for fame or recognition. Yet there is no doubt that she would welcome the reader to "come and look" at her writings and watercolors—with "heartsight" as well as "eyesight."

A Blossom in the Desert introduces to you the vision—visible and invisible—of the remarkable Lilias Trotter! Come. Look. See!

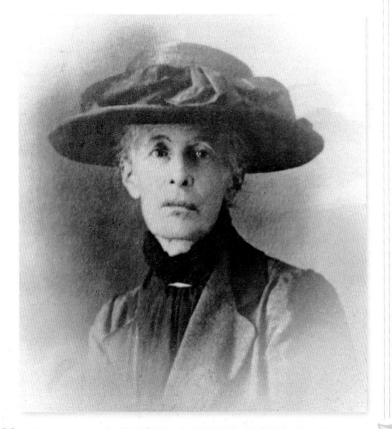

I. Lilias Trotter, 1853–1928

I am now ready to be offered.

Measure thy life by loss
and not by gain,
Not by the wine drunk, but
by the wine poured forth,
For love's strength standeth in
love's sacrifice,
And he who suffers most has most to give.

Light

The Son is the radiance of God's glory and the exact representation of his being, sustaining all things by his powerful word.

Hebrews 1:3

The Radiance of Christ

The Unveiled Face of Jesus

The sun was rising behind a huge Ferpeck glacier which stood in dim blue against a darker blue sky. The huge pyramid of the Dent Blanch, out of sight, cast its shadow athwart it. Pinnacle after pinnacle of ice caught the brilliance as the sun rose behind it in some places, while in others there were stretches of reflected light from unseen snowfields beyond. Oh the difference, in parable and in reality, between the stretches of light that reach us secondhand and the gleams that come pure and radiant from the unveiled face of Jesus!

Now we see but a poor reflection as in a mirror;
then we shall see face to face.

1 Corinthians 13:12

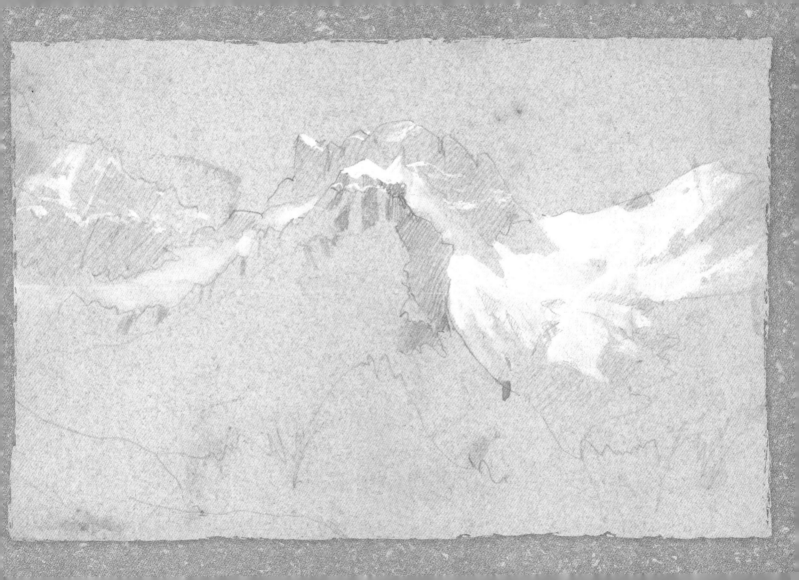

And we have the word of the prophets made more certain, and you will do well to pay attention to it, as to a light shining in a dark place, until the day dawns and the morning star rises in your hearts.

2 Peter 1:19

The Morning Star

The morning star is so perfectly marvellous these days. It hangs in the dawn like a great globe of silver fire. Of all the images of Christ it seems the one that is almost more than an image—it is so utterly like Him in its pure glory. And it sets one's heart crying for the promise "I will give him the morning star"—the revelation of Himself to the watching ones.

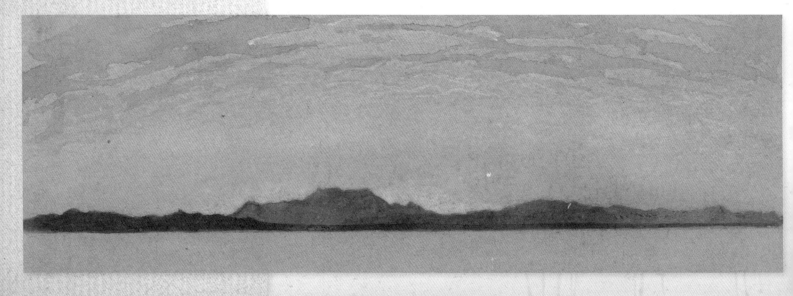

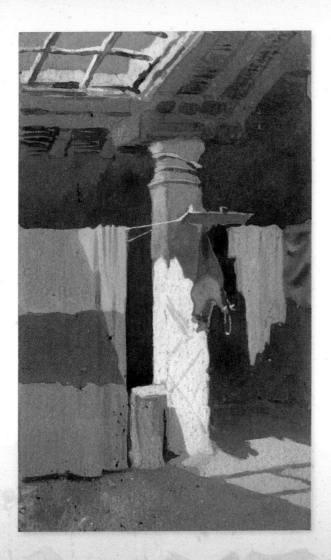

Shaft of Light

"The word of the Lord" has come these mornings with the stealing, day by day, of a tiny circle of light across the wall as soon as the sun is up. It comes through a wee chink in the weatherworn shutter—just one shaft—but it is the image of the Sun Himself, full-orbed. And it has come with a flood of joy that no matter if we are only crooked little chinks, the heavenly Sun can send through us not only light, but the revelation of His Image: "the light of the knowledge of the Glory of God in the Face of Jesus Christ!"

~

Now you are light in the Lord. Live as children of light.

Ephesians 5:8

Let us fix our eyes on Jesus, the author an

erfecter of our faith.

Hebrews 12:2

Turn Your Eyes Upon Jesus

It was in a little wood in early morning. The sun was climbing behind a steep cliff in the east, and its light was flooding nearer and nearer and then making pools among the trees. Suddenly, from a dark corner of purple brown stems and tawny moss, there shone out a great golden star. It was just a dandelion, and half withered—but it was full face to the sun, and had caught into its heart all the glory it could hold and was shining so radiantly that the dew that lay on it still made a perfect aureole round its head. And it seems to talk, standing there—to talk about the possibility of making the very best of these lives of ours.

For if the Sun of Righteousness has risen upon our hearts, there is an ocean of grace and love and power lying all around us, an ocean to which all earthly light is but a drop, and it is ready to transfigure us, as the sunshine transfigured the dandelion, and on the same condition— that we stand full face to God.

Look at Jesus

Today's story is a very pretty one. The little pickle Melha went right up to her nearly blind father and pointed to one of the pictures on the wall—one of the Lord calling a little child to Him—and said, "Look at Jesus."

"I have no eyes, O my daughter—I cannot see," was the answer.

The baby thing lifted head and eyes to the picture and said, "O Jesus, look at father!"

Was not that a bit of heavenly wisdom?

My eyes will watch over them for their good.

Jeremiah 24:6

The Baby Moon

The baby new moon was hanging in the sunset tonight like a boat for the little angels—so the battle month is over again.

This verse has come with a flood of fresh inspiration to hope.

O Lord, my strength and my fortress, my refuge in time of distress, to you the nations will come from the ends of the earth and say, "Our fathers possessed nothing but false gods, worthless idols that did them no good." . . . Therefore I will teach them—this time I will teach them my power and might. Then they will know that my name is the Lord.

Jeremiah 16:19, 21

Soul Vision

This is the true inward vision, the faith of seeing, as distinct from the faith of deductive proof. It is an illumination that abides from the beginning, not merely flashes of light that visit you from time to time when you have reached a certain stage. For this light is not to be sought within the recesses of your being but outside yourself and away in another, even in Him who God has sent to be the Light of the World. Once for all, here and now, this light will break on you if you lift up your eyes and behold Jesus Christ with the spiritual vision of the soul.

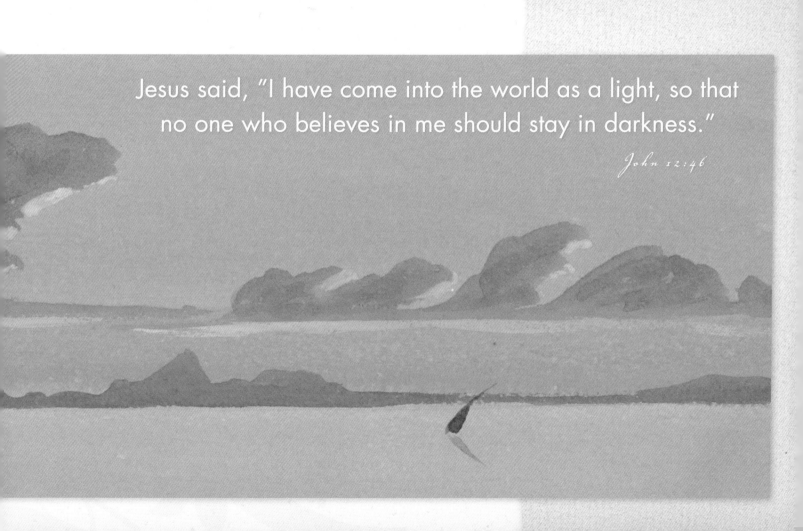

Jesus said, "I have come into the world as a light, so that no one who believes in me should stay in darkness."

John 12:46

We wait for the blessed hope—
the glorious appearing of our
great God and Savior, Jesus
Christ, who gave himself for us
to redeem us from all wickedness
and to purify for himself a
people that are his very own,
eager to do what is good.

Titus 2:13–14

Dawn

A weaving of light and shadow, as the old year dies. But they are the
light and shadows not of sunset, but of dawn—a dawn that will turn its
dreams into realities.

> "A dim aurora rises in my East
> Beyond the line of jagged questions hoar
> As if the head of our intombed High Priest
> Began to glow behind the unopened door:
> Sure the gold wings will soon rise from the gray!
> They rise not. Up I rise, press on the more,
> To meet the slow coming of the Master's day."

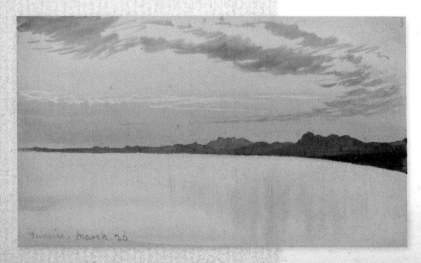

sunrise, March '96

Until the day breaks and the shadows flee...

Song of Songs 2:17

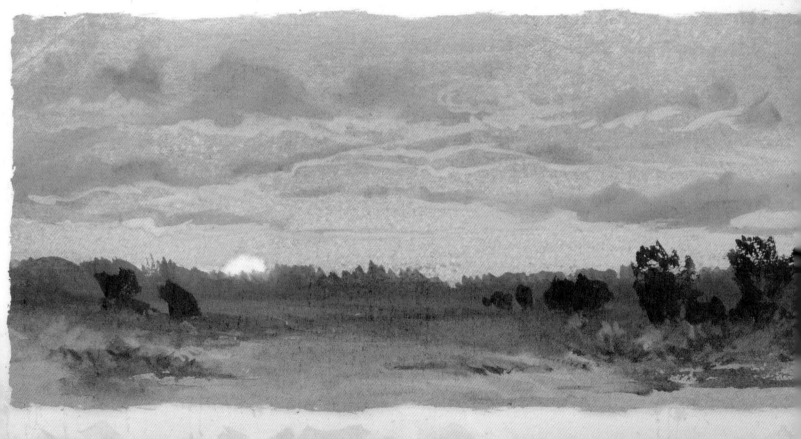

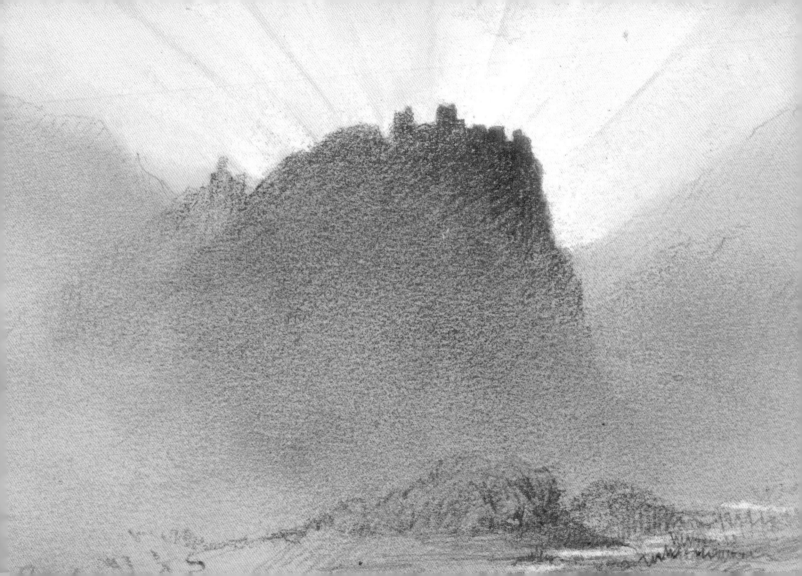

When the Day Breaks

*A word full of comfort concerning the secret disciples of these lands came to me this morning in
Malachi. For they do fear the Lord and speak often one to another and think upon His name—
though as yet their witness goes no further. Yet to such is the promise given, "'They shall be mine,'
saith the Lord of hosts, 'in that day when I make up my treasured possession.'"
There will be a flashing out from many an unheeded corner when "that day" breaks!*

A scroll of remembrance was written in his presence
concerning those who feared the Lord and honored his name.
"They will be mine," says the Lord Almighty, "in the day
when I make up my treasured possession. I will spare them,
just as in compassion a man spares his son who serves him."

Malachi 3:16–17

Now faith is being sure of what we hope for and certain of what we do not see.

Hebrews 11:1

Faith

Light

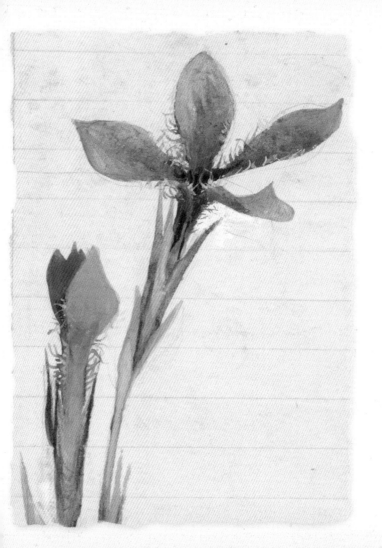

Autumn Crocus

I have just been finding that the bride's words "I am the Rose of Sharon" in the Revised Version are rendered "the autumn crocus."

It is the snowdrop, as it were, of these lands: breaking out of the hard dry ground and laughing at the barrenness of everything around in its faith that the rains are coming, when there is hardly "a cloud like a man's hand" above the horizon.

The desert and the parched land will be glad;
the wilderness will rejoice and blossom.
Like the crocus, it will burst into bloom;
it will rejoice greatly and shout for joy.

Isaiah 35:1–2

The First Cyclamen

The first cyclamen—with their little angel wings all flying with joy, though only the first warm quickly-dried drops have visited the earth yet, and it looks as baked and hopeless as ever. "Not having received the promises but having seen them afar off"—that is what they say.

God must love that sort of faith just as we love the bits of cyclamen that have greeted "afar off" the coming showers and fought through with their rosy flowers with only the dry brittle tangle of burnt-up grass to protect them from the scorch of the sun.

❧

Hope that is seen is no hope at all . . . But if we hope for what we do not yet have, we wait for it patiently.

Romans 8:24–25

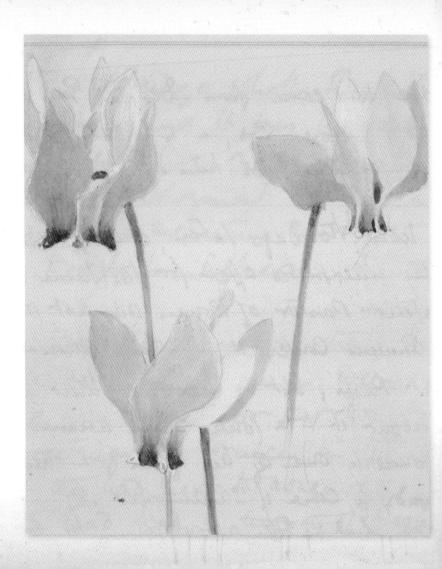

Clouds

Things still look dark and heavy all round—but "when the clouds be full of rain they empty themselves upon the earth." It is better to wait as the parched ground waits here, for the torrents that will set life going.

If clouds are full of water,

they pour rain upon the earth.

Ecclesiastes 11:3

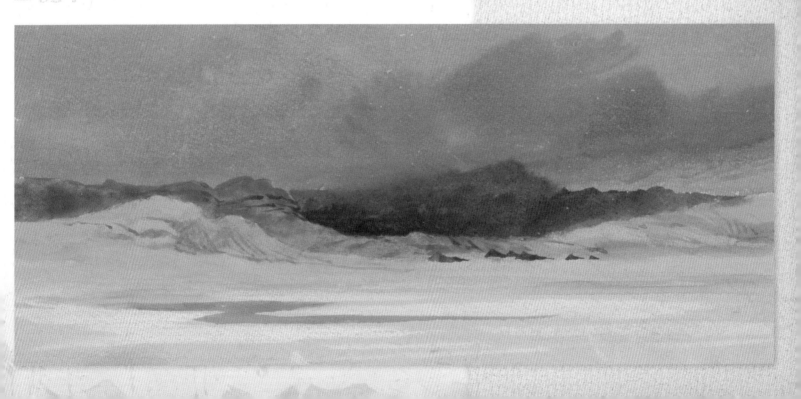

Trained Faith

"As an eagle . . . fluttereth over her young, spreadeth abroad her wings, taketh them, beareth them on her wings—so the Lord alone did lead him."

Fluttereth over—the early stages of faith are reaching upward, like the eaglets for their food when the mother-bird is overhead. It is an older faith that learns to swing out into nothingness and drop down full weight on God—the broken-up nest of former "experiences" left behind—nothing between us and the abyss but God Himself. Trained faith is a triumphant gladness in having nothing but God—not rest, no foothold—nothing but Himself. A triumphant gladness in swinging out into that abyss, rejoicing in every fresh emergency that is going to prove Him true. "The Lord alone"—that is trained faith.

He shielded him and cared for him; he guarded him as the apple of his eye, like an eagle that stirs up its nest and hovers over its young, that spreads its wings to catch them and carries them on its pinions.

Deuteronomy 32:10–11

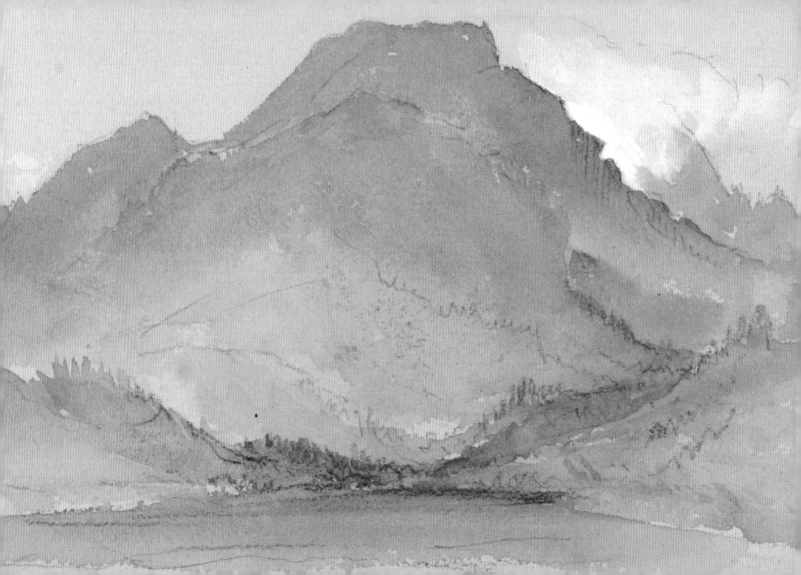

Faith with a Spring

I am beginning to see that it is out of a low place that one can best believe. It is water poured down into a low narrow channel that can rise into a fountain. Faith that comes from the depths has a spring in it!

I will make rivers flow on barren heights, and springs within the valleys. I will turn the desert into pools of water, and the parched ground into springs.

Isaiah 41:18

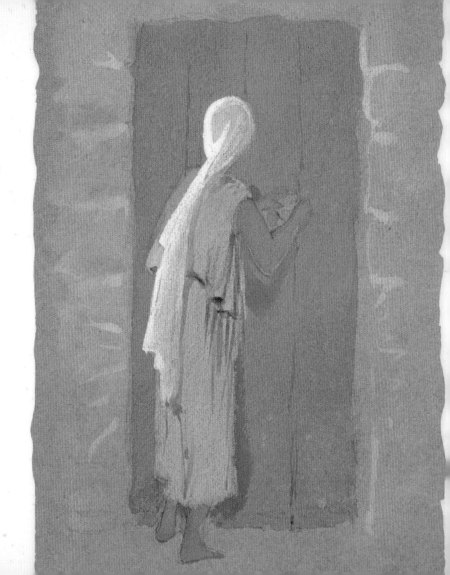

Believe!

Believe in the darkness what you have seen in the light.

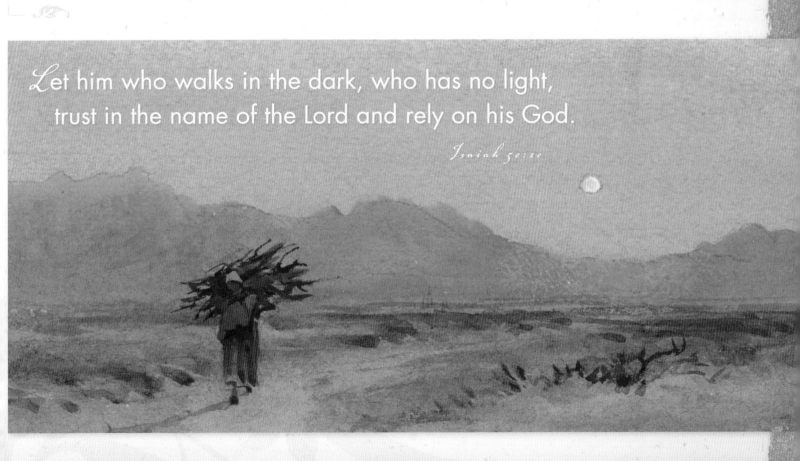

Let him who walks in the dark, who has no light,
 trust in the name of the Lord and rely on his God.

Isaiah 50:10

from Clarens. Sept. 12.

Sails to the Wind

I am seeing more and more that we begin to learn what it is to walk by faith when we learn to spread out all that is against us: all our physical weakness, loss of mental power, spiritual inability—all that is against us inwardly and outwardly—as sails to the wind and expect them to be vehicles for the power of Christ to rest upon us. It is so simple and self-evident—but so long in the learning!

My grace is sufficient for you, for my power
is made perfect in weakness.

2 Corinthians 12:9

Glimmer of Light

In the garden there is an African "soldanella"—not a real soldanella—only an African version of the same truth of the wonders that God can do in secret. A garden border of a kind of thick matted grass, a foot high—so matted that the leaves were bleached yellow-white for want of sun, for a full third of their length.

The Lord turns my darkness into light.

2 Samuel 22:29

But right down below that level—almost on the ground—with barely a ray of light, its berries had ripened to wonderful sapphire blue-like jewels when one parted the mass and came upon them. Oh our God can do the same miracles with this tiny glimmer of light that comes to these souls in their tangle of darkness. Glory be to His name!

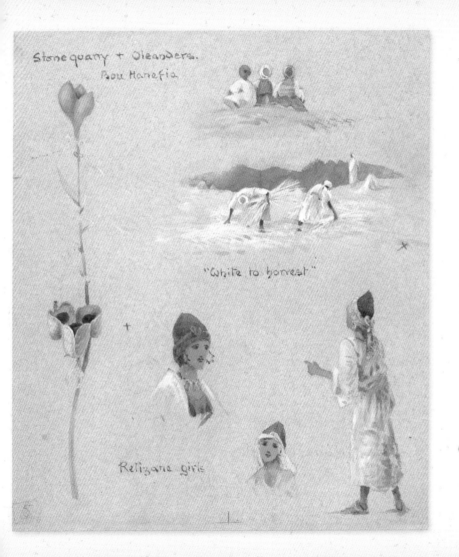

Stonequarry + Oleanders.
Paou Hanefia

"White to harvest"

Relizane girls

Stretched-Out Hand

These last days have been full of faith lessons…
They have come out of the first few chapters of Exodus,
over the rod and the stretched-out hand of Moses.
The linking of the stretching out of that weak human
hand with the mighty hand of God is so wonderful.
"I will stretch out My Hand"—that was the first
promise—and it was worked out by Moses stretching
out, in his weakness, the hand of faith below.

The stretched-out hand of faith on earth, acting
in union with the stretched-out hand of God's power
in heaven. That is the sort of faith we have got to learn
before we have done with it.

Surely the arm of the Lord is not too short to save,
nor his ear too dull to hear.

Isaiah 59:1

The Blissful God

The thistles here are a commentary to me on that wonderful
title of 1 Timothy 1:11—"The Blissful God." It is as if now
that not a flower is left on the barren ground, His gladness
and His beauty must pour itself out on something still, so
He takes the thistles and glorifies them. Not even living
thistles but dead ones—for the flower and even the seed
have gone from them for the most part now. "Will He not
much more clothe you, O ye of little faith!"

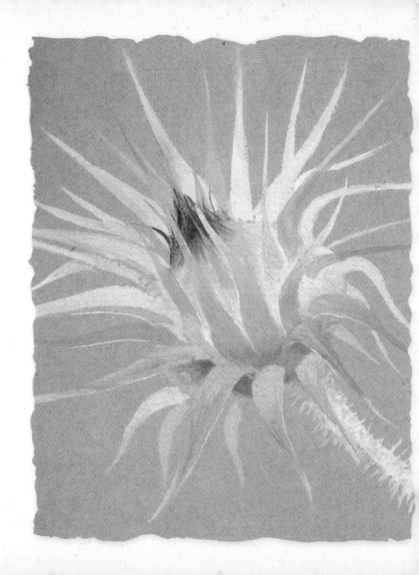

Jesus said, "Consider how the lilies grow. They do not
labor or spin. Yet I tell you, not even Solomon in all his
splendor was dressed like one of these. If that is how
God clothes the grass of the field, which is here today,
and tomorrow is thrown into the fire, how much more
will he clothe you, O you of little faith!"

Luke 12:27–28

Deep Waters

"I am come into deep waters" took on a new meaning this morning. It started with perplexing matters concerning the future. Then it dawned that shallow waters were a place where you can neither sink nor swim, but in deep waters it is one or the other: "waters to swim in"—not to float in. Swimming is the intense, most strenuous form of motion—all of you is involved in it—and every inch of you is in abandonment of rest upon the water that bears you up.

"We rest in Thee, and in Thy Name we go."

Find rest, O my soul, in God alone;
my hope comes from him.

Psalm 62:5

The prayer of a righteous man is powerful and effective.

James 5:16

Prayer

Light

Noria in the Garden

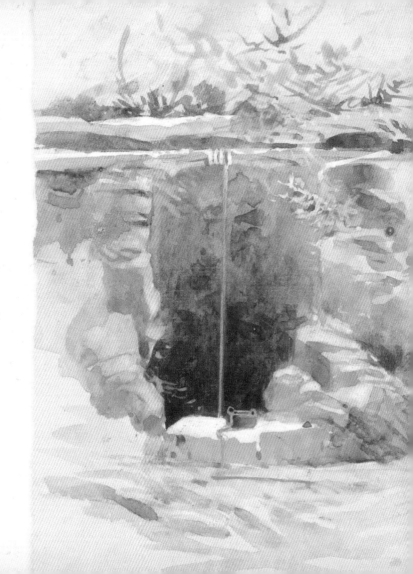

The Noria in the garden has taught a prayer-lesson today. At the very first turn of the wheel that works it, a cupful of the clear cold water deep down is dipped up—but it does not reach the surface at once. Many and many a "godet" comes up first—dry, empty, iron. It is all on the way to the full one that is coming. More than that, each disappointing godet that looks as if it might be the expected one and fails to be, and goes back as it came, means another full cup coming up, if only we go on turning. For once the first has risen brimming over, every fresh turn means another and another outpour. The prayer-disappointments are all part of the prayer-answers that are coming—linked as securely as the godet links of the Noria, and working out the one objective.

Do not be anxious about anything, but in everything, by prayer and petition, with thanksgiving, present your requests to God.

Philippians 4:6

Praying Downwards

It has come these days with a new light and power, that the first thing we have to see to, as we draw near to God day by day, is that "our fellowship is with the Father and with His Son Jesus Christ." If we can listen in stillness, till our hearts begin to vibrate to the thing that He is thinking and feeling about the matter in question, whether it concerns ourselves or others, we can from that moment begin praying downwards from His throne, instead of praying upwards towards us.

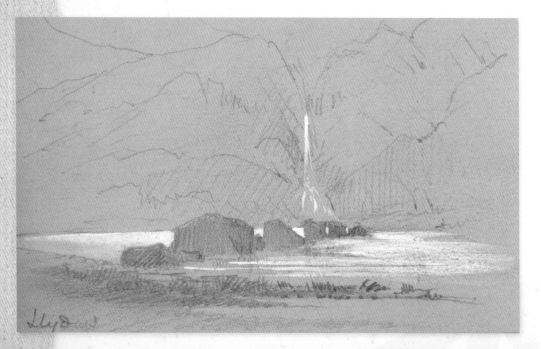

This is the confidence we have in approaching God: that if we ask anything according to his will, he hears us. And if we know that he hears us—whatever we ask—we know that we have what we asked of him.

1 John 5:14–15

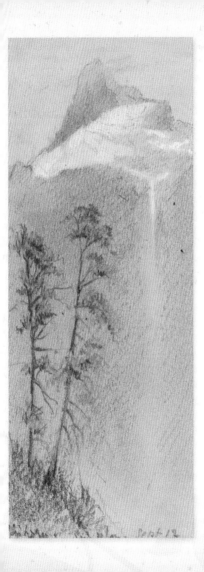

Catching His Thought

Echoes from Keswick seem to link in with teaching that has been coming here in the quietness about prayer—how all the tenor of helplessness and failure over it is only meant to make way for the prayer life of Christ in us and fellowship with Him in which He will "make all things new." No longer a weary wrestling to get access and an answer, but catching His thought and swiftly asking alongside in His name—His the overtone, ours the undertone, so to fill in the harmony.

Praying down rather than praying up—that is the summing up: how that the velocity and power of anything that comes down, gains in a ratio of high proportion with the height from which it drops. Even from an airplane, a pencil falling will take on the force of a bullet. What might not our prayer power be if it comes down the throne of the Priest, linked with Him.

"Prayer is the true lasting will of the soul, united and fastened into the will of our Lord by the sweet inward working Holy Ghost"—so was it defined by Mother Julian of Norwich four hundred years ago.

We do not know what we ought to pray for, but the Spirit himself intercedes for us with groans that words cannot express.

Romans 8:26

Standing in Spirit

"Prayer is to us the opening of the sluice-gate between my soul and the Infinite." I came on those words of Tennyson's the other day, and they came back again and again today with a special sense of the reality with which, instantly and unfailingly, the taking in the Name of Jesus for this and that village and for all those dear unreached and unreachable mountains and deserts does set the sluicegates open to them. The powerlessness to go gives an intensity to the joy of it.

One can stand in spirit among the dear mud-houses of Tolga, and the domed roofs of the Souf, and the horseshoe arches of Touzer, and the tiled huts buried in prickly-pear hedges in the hills, and bring down the working of the Holy Ghost—by faith in that Name— perhaps more effectually than if one were there bodily. One can "shut the door," as it were, and stand alone with God over it, as one cannot do on the spot, with the thronging outward distractions of the visible. The fountains in the gardens here spoke of that yesterday. It is the narrowness of the hemmed in channel from the hill that sends it springing.

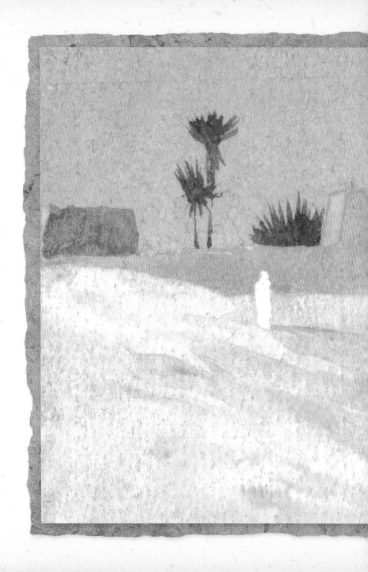

We live by faith, not by sight.

2 Corinthians 5:7

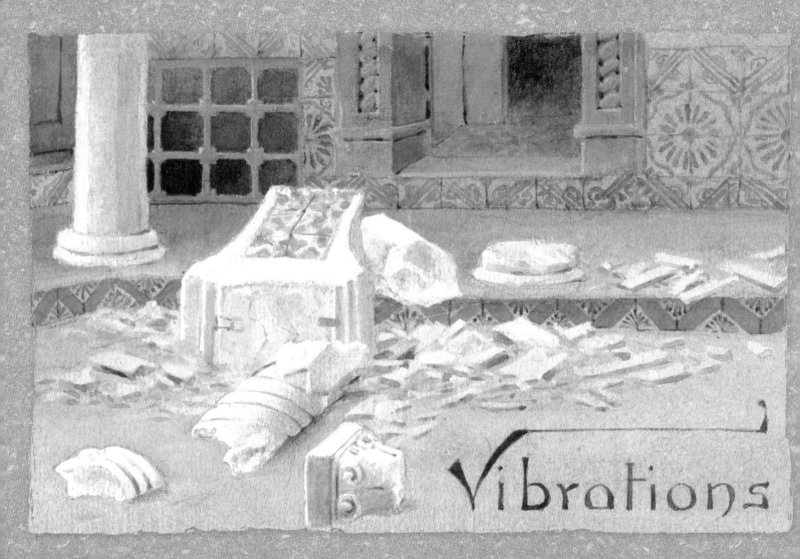
Vibrations

Vibrations

There is a vibrating power going on down in the darkness and dust of this world that can make itself visible in starting results in the upper air and sunlight of the invisible. Each prayer-beat down here vibrates up to the very throne of God, and does its work through that throne on the principalities and power around us. We can never tell which prayer will liberate the answer, but we can tell that each one will do its work.

"If we ask any thing according to his will, he heareth us. And if we know that he hear us . . . we know that we have the petitions that we desired of him."
(1 John 5:14–15)

Pray continually.

1 Thessalonians 5:17

Fire Upwards!

A story of the wars of the first Napoleon has often come back to me. He was trying, in a winter campaign, to cut off the march of the enemy across a frozen lake. The gunners were told to fire on the ice and break it, but the cannon-balls glanced harmlessly along the surface. With one of the sudden flashes of genius he gave the word, "Fire upwards!" and the balls crashed down full weight, shattering the whole sheet into fragments, and the day was won.

We can "fire upwards" in this battle, even if we are shut out from fighting it face to face. If God calls us there in bodily presence, we will never be able to pray to any purpose, or work to any purpose either, except there; but if He does not summon us, we can as truly, as effectually, as prevailingly, do our share within the four walls of our rooms.

Is Jesus Not Enough?

The thought of Christ's intercession has taken on a new preciousness these last days. I was reading how God had given a wonderful gift of prayer to two friends. They would fight through together till His answer came over in showers. And the thought came—oh that we had someone among us here able to pray like that. Then with the vividness of an audible voice almost, the thought came: "Is not Jesus enough?" Since then, the sense of praying with Him alongside has been so beautiful.

⁓

I consider everything a loss compared to the surpassing greatness of knowing Christ Jesus.

Philippians 3:8

Giving Our Amen

More and more one sees that prayer is a quiet time for thinking out God's thoughts with Him and giving our "Amen" in the Name of Jesus. Was it not Galileo, when the light of some great astronomical law broke on him—or was it Newton?—who fell on his knees and said, "I praise Thee, O God, that Thou has let me think a thought that Thou has been thinking."

"No eye has seen, no ear has heard, no mind has conceived what God has prepared for those who love Him"— but God has revealed it to us by his Spirit. The Spirit searches all things, even the deep things of God.

1 Corinthians 2:9—10

The Vault of Heaven

They say that as you stand under the dome in the Pisa cathedral, the faintest utterance, even if discordant, is taken up by echo after echo in ever-increasing volume overhead, and rained down again like the song of angels. Will the vault of heaven do less?

And my God will meet all your needs according to his glorious riches in Christ Jesus.

Philippians 4:19

The Lord's Prayer

I have been praying the Lord's Prayer with special intention for Ali. It is such a wonderful vehicle
for intercession if one puts it in the third person instead of in the first:

"That the Father's name may be hallowed in him"

"That His Kingdom come and His will be done"

"That he may have his daily bread and the Father's forgiveness"

"That he may not be led into temptation but may be delivered from the evil one"

"For in Him is the Kingdom and the power and the glory."

"Our Father in heaven,
 hallowed be your name,
 your kingdom come,
 your will be done
 on earth as it is in heaven.
 Give us today our daily bread.
 Forgive us our debts,
 as we also have forgiven our debtors.
 And lead us not into temptation,
 but deliver us from the evil one."

Matthew 6:9–13

But when he, the Spirit of truth, comes, he will guide you into all truth.

John 16:13

Holy Spirit

Light

You, however, are controlled not by the sinful nature but by the Spirit, if the Spirit of God lives in you.

Romans 8:9

Minding of the Spirit

God speaks so through all living things. Last time it was through a rushing mighty wind that filled the valley. The trees took it in such a different way. They are nearly all juniper and eucalyptus, and their different natures so came out under it. The junipers, tough and stubborn, only moving when by sheer force they had to move, and that in an ungracious combative manner, springing back instantly to their former position. The eucalyptus, on the other hand, had every leaf so posed that not a breath passed unheeded—while a little gust would ripple and toss their heads about, and a stronger one would sway their very centers. When the breath died down, instead of a willful rebound like the junipers, they would just relax and hold still—still enough to catch again the first whisper of the wind.

It was such a picture of the "minding of the Spirit" which is "life and peace," while the junipers stood in control as those who "minding the things of the flesh" are "not subject unto the law of God." One does want to be sensitive to His every breath.

Smoldering

Another parable lesson has been before our eyes these last days—a little cloud of thin blue smoke has been hovering over a certain spot on the opposite side of the valley. At last I asked what it was.

"Oh, it is a larch tree—a woodcutter lit his fire under it a week ago to cook his dinner and it has been alight ever since."

"But it will spread, will it not?"

"No—there is no flame, so it cannot spread," was the answer.

And so it was. Damp with the mists that rose around, and with the sap of its own life within, it smoldered on till we left, and nothing else was set alight.

He will baptize you with the Holy Spirit and with fire.

Matthew 3:11

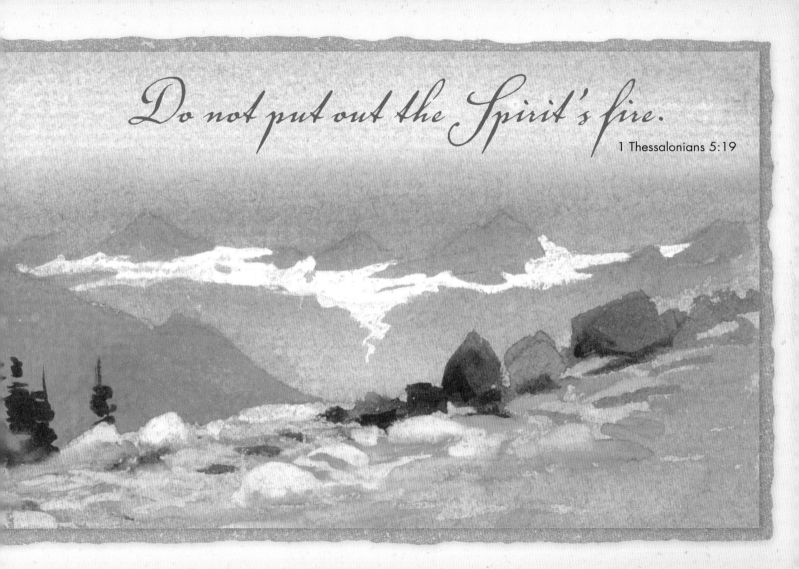

Weight of Glory

The grass has to stand very still as it holds its precious "weight of glory"—and so has the soul on whom the dew of the Spirit comes. Literally, as easily as this dew, His dew is brushed off—some of us know it to our cost. An impulse of impatience, a sense of hurry or worry allowed to touch us, a mere movement of the self-life against His checking, and He is gone, and our soul stands stripped and bare. Noiseless must be His Holy Habitation within us.

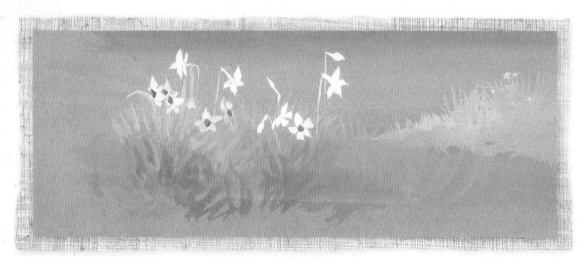

In repentance and rest is your salvation,
in quietness and trust is your strength.

Isaiah 30:15

Give Us Fire

"Give us fire"—two little upturned faces and an outstretched potsherd—a request that no Arab would refuse, even if she has but a crumb of live coal left. "Give us fire," our hearts echo up to Him who sees our need as the working days draw near again.

You, O Lord, keep my lamp burning;
my God turns my darkness into light.

Psalm 18:28

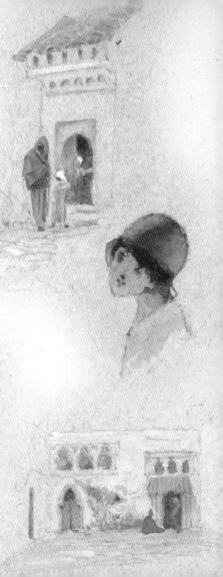

"come."

"finished"

A River Lesson

And another river lesson has come with the words, "His voice was as the sound of many waters."
I have never noticed before how such a thing will check the voice of their torrent. A rock, a
bush, even water running will dull it from a thunder of power into a mere whisper where all the
harmony of its multitude of tone is deadened and lost. Oh, we want to live where not one of the
undertones or overtones of His Voice is stifled or missed!

Jesus said, "Whoever believes in me, as the Scripture has said,
streams of living water will flow from within him." By this he meant
the Spirit, whom those who believed in him were later to receive.

John 7:38–39

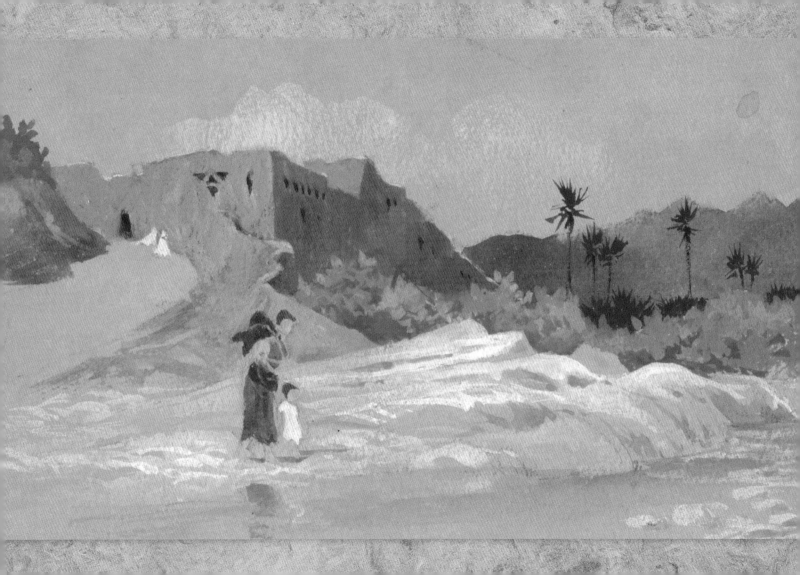

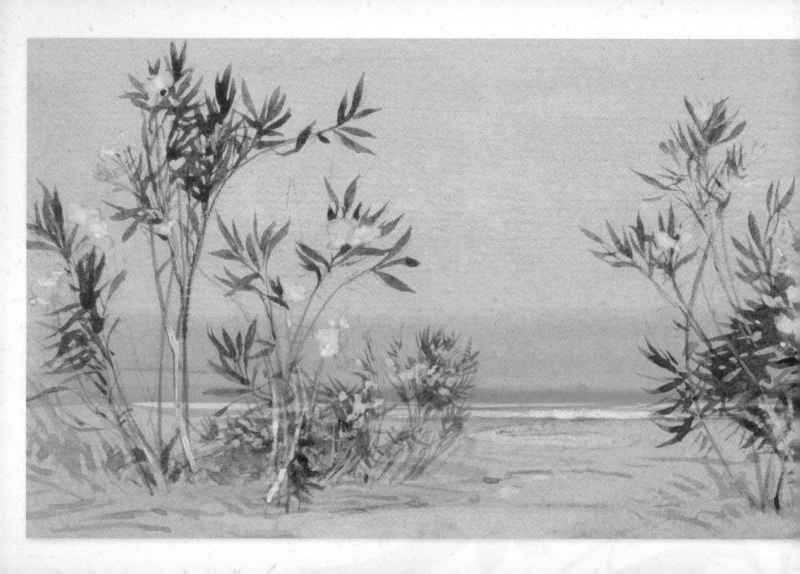

Sweet Grace from Above

The springs teach us that the in-dwelling Spirit whom we have received by faith holds sway over our hearts by heavenly impulses, that throb within us like the pulsing we have all noticed in living water. If we respond to that urging, He is set free in power: He is the Spirit whom God has given to all them that obey Him.

The needs-be is that we should yield to His touch, in heart-sensitiveness and quick, full co-operation, whether the inward call is to action, or utterance, or prayer, letting Him work His way, as the hidden spring frees the silted channel—our aim, as Faber puts it, "only not to impede the sweet grace from above." The measure and the swiftness of our yielding will be the measure of the putting forth of His power.

"Not by might nor by power, but by my Spirit," says the Lord Almighty.

Zechariah 4:6

Trust in the Lord with all your heart
and lean not on your own understanding;
in all your ways acknowledge him,
and he will make your paths straight.

Proverbs 3:5–6

Guidance

Light

God's Guidance

The word of the Lord has come these days in the story of the pillar of clouds and fire. The cloud spread for a covering links on with Colossians 3:15—"Let the peace of God legislate." There is such a sense of infinite rest in the desert in being under a great shadow. It seems to bring a cool river of peace through all one's being. God's guidance, if our soul's instinct is healthy, tallies with the sense of rest. In a very real way, this sense of rest guides us—legislates for us. Anything that brings a sense of restlessness means that we have got from under the cloud shadow: we have gone off on some self-devised path, or we have not kept pace with God; we have slackened and got left behind. It is the same in cases of perplexity—where there is no clear command in His word to guide us—where the sense of rest falls (always taking for granted that our wills are in His Hand) there is His path. It is there that the shadow of His cloud is falling.

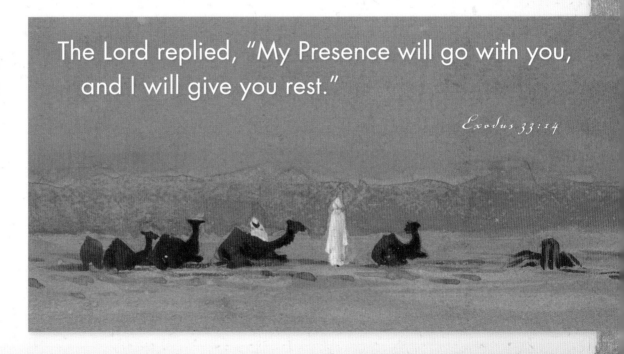

The Lord replied, "My Presence will go with you, and I will give you rest."

Exodus 33:14

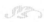

Mountain Lesson

He leads me beside quiet waters,
he restores my soul.

Psalm 23:2–3

Today's "first lesson" was in these little mountain paths. I followed mine only a few yards further this morning and such an outburst of beauty came. You can never tell to what untold glories a little humble path may lead, if you follow far enough.

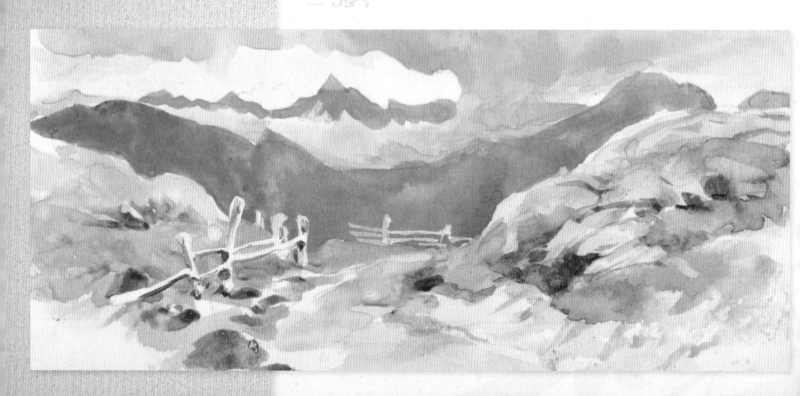

A Swifter Path

It will be beautiful to watch on and see how, for the outward leadings as well as for the inward dealings of His Spirit, God's pillar of fire and cloud has never failed in His initiative—so that nothing has been needed but a quiet following under the light and the rest of His going before.

It ought to take us shorter time as we go on to learn our lessons and to trust and not be afraid, just as the spiral comes round by a swifter path as it nears its summit.

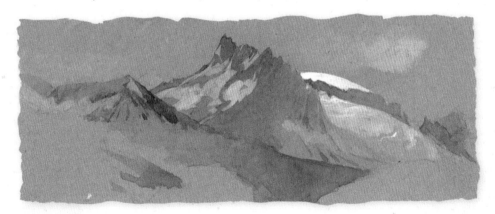

Let us draw near to God with a sincere heart
in full assurance of faith.

Hebrews 10:22

God's Initiation

> "The Lord shall go before thee
> and the God of Israel shall
> gather thee up."

Do we not see sometimes that God begins, as it were, by taking the initiative and letting us simply follow on with Him. Then the obvious leading ceases. He is there, but He has withdrawn the pillar of cloud from before us, and asks us to go on in bare faith, while He is shielding and separating us in ways out of our ken, from the dangers that are seen by Him alone.

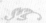

I guide you in the wa

wisdom and lead you along straight paths.

Proverbs 4:11

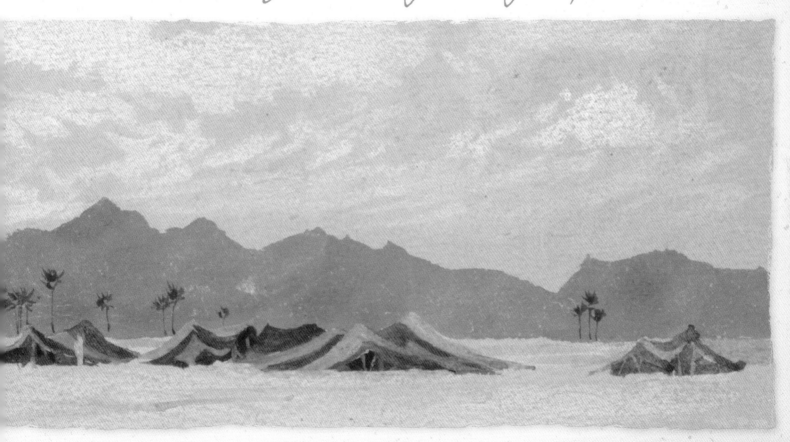

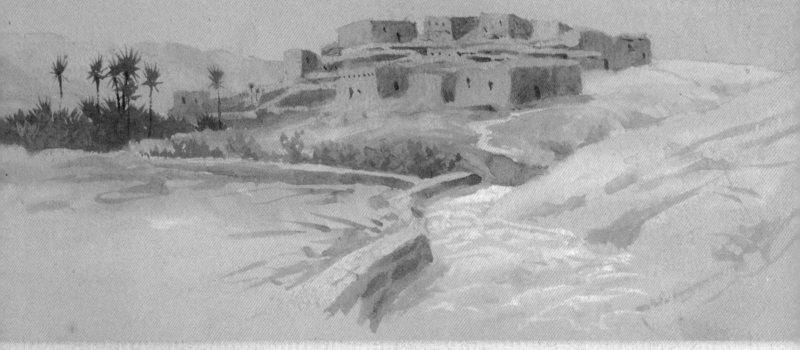

Lead me, O Lord, in your righteousness
because of my enemies—
make straight your way before me.

Psalm 5:8

Quiet Certainty

I am beginning to see that in God's work it is a dangerous thing to let even thoughts and longings stray unbidden by Him. Before we know it we may have to go out of our trenches, so to speak, into a spiritual no-man's-land where we and the work are a mark for the enemy. "Let me not wander out of Thy commandments."

And in every inward experience and every outward bit of service, He puts the seal of His "Amen" in a way that is known to us and to Him. The inward hush of the "It is finished."

If the Lord delights in a man's way,
he makes his steps firm;
though he stumble, he will not fall,
for the Lord upholds him with his hand.

Psalm 37:23-24

The heavens declare the glory of God;
the skies proclaim the work of his hands.
Day after day they pour forth speech;
night after night they display knowledge.

Psalm 19:1–2

God's Primer

Light

Hide and Seek

The great amphitheatre that closes in the valley, in the deepest sombre rich colouring below for the undergrowth of bilberry and oak fern, is turning every shade of tawny red and gold among the deep fir trees. And far above the whole range of snowy crests were playing hide and seek between two layers of cloud, showing glimpses of pure glacier, like steps to the great white Throne.

By the word of the Lord were the heavens made,
 their starry host by the breath of his mouth.
He gathers the waters of the sea into jars;
 he puts the deep into storehouses.
Let all the earth fear the Lord;
 let all the people of the world revere him.
For he spoke, and it came to be;
 he commanded, and it stood firm.

Psalm 33:6–9

Light Chasing Darkness

One hears of the light chasing the darkness—but I never saw it done before. It was literally hunted and driven down due west in the sunrise into this great bay of sky between the Matterhorn and the Obere Gabelhorn. When I went to keep watch in the front of the house at quarter to five, the sky was still soft lavender blue. Then came from the zenith a flush of violet, sweeping the blue down to the snow of the skyline—and that was chased down by mauve, and the mauve by dim rose colour, and the rose by apricot. Then the peak of the Matterhorn flamed up in brilliant rose and madder—and the day has come.

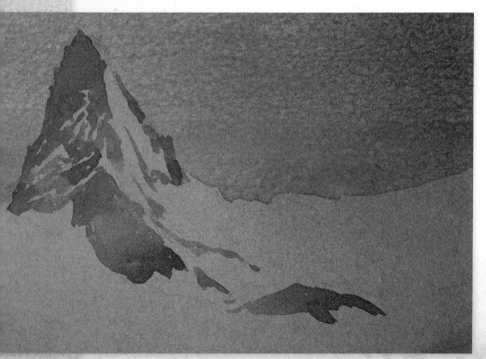

Many, O Lord my God,
 are the wonders you have done.
The things you planned for us
 no one can recount to you;
were I to speak and tell of them,
 they would be too many to declare.

Psalm 40:5

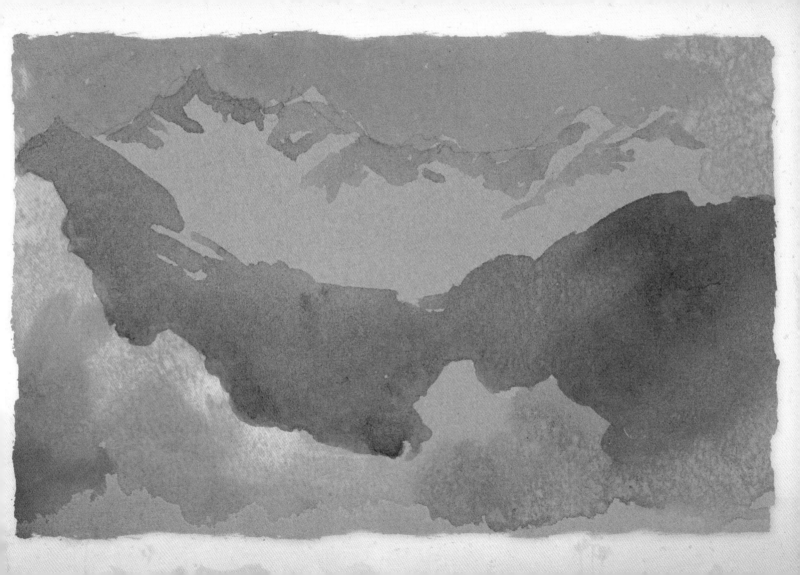

February Flowers

The spring flowers that stand all about my room in Arab pots of green and yellow earthenware bring a very real revelation of Him "by whom were all things created." The clear happiness of the daisies, and the radiant shout of the celandines, and the deep sweet joy of the great almond blossoms with their mystical hearts—all are literal foreshadowing of the "gladness above His fellows."

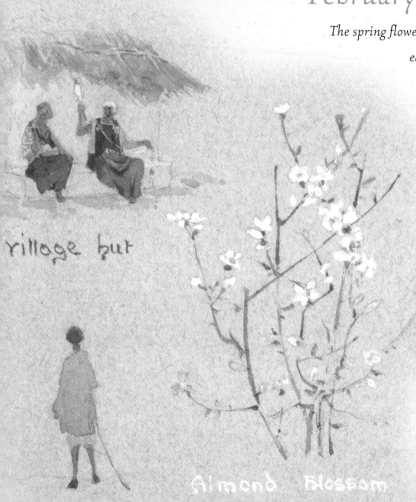

village hut

Almond Blossom

Come and see what God has done,
how awesome his works in man's behalf!

Psalm 66:5

Harbinger of Spring

The long hard winter has broken at last—not as yet in much sign on the earthward side, but in the late afternoon yesterday the great cumulus clouds sank away, and in their place lay long horizontal bars, one above the other, dove-grey touched with pale apricot, upon the tender eggshell blue of the eastern sky. They are a harbinger of spring out here, that I have never known to fail.

The day is yours, and yours also the night;
 you established the sun and moon.
It was you who set all the boundaries of the earth;
 you made both summer and winter.

Psalm 74:16–17

Wave Offering

*The cornfields here have been so beautiful.
One thing we like to watch is a curious
gesture with which the women reapers swing
the sheaf over their heads, like a kind of
wave-offering, standing up against the great
icy stair of the glacier beyond.*

Then the land will yield its harvest,
 and God, our God, will bless us.
God will bless us,
 and all the ends of the earth will fear him.

Psalm 67:6-7

*Peacemakers who sow in peace
raise a harvest of righteousness.*

James 3:18

Harvest Time

Down here for a fortnight rest and writing—so ideal—visits before have been too short for letting oneself go to its atmosphere. The harvest is just in, and thank God a good one. The land is a vision of beauty in the care of its shibble fields and the old rose and mauve of its distances. The riverbed is a very garden of the Lord in its clusters of oleander in full flower—from the faintest blush-white to deep carmine buds and every intervening shade of rose colour nestled in their sword like leaves. Better, in the eternal light than the earthy harvest-time, is that the first grains from the heavenly storehouse are being steadily dropped now into the furrows.

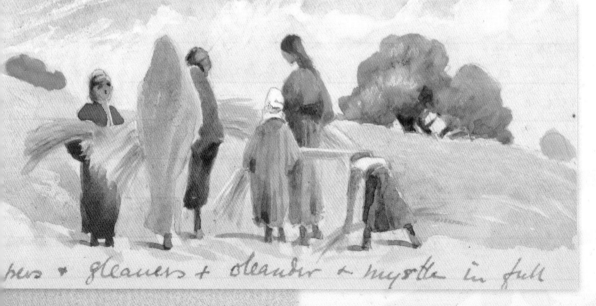

hers + gleaners + oleander + myrtle in full

Bell of Blida

The sense of Epiphany came before the dawn in the tremulous clanging of the church bell of Blida.
So gentle at first that it might almost have been the tinkling bells of the wise men's camels—a growing into
a crescendo of joy, as will that "manifestation" come to be at a better daybreak.

Clap your hands, all you nations; shout to God with cries of joy.
How awesome is the Lord Most High, the great King over all the earth!

Psalm 47:1–2

Olive Trees

They were ranged in their terraces on the mountainside, by scores and hundreds, each more quaint than his fellow, till one could hardly choose which should be put on paper. "Unto the end" echoed from them all. They had outlasted, some of them, to men's knowledge, five hundred years of scorching drought and winter storm. Branches that had seemed needful for symmetry had been pruned off one after another, to concentrate the life current in those that remained. There were many whose very foothold had been almost swept away, and yet they reared themselves on stilt-like roots—immovable. The writhe and the wrestle had penetrated every fibre and muscle and told its own story in silence; and now they stood against the autumn blue of the sea below, their silvery crowns shimmering in a great peace, intent only on fruit-bearing to the last remnant of their days.

Country man

But I am like an olive tree
 flourishing in the house of God;
I trust in God's unfailing love
 for ever and ever.

Psalm 52:8

The beginning of the olivegroves

Hills of Touzer

As we neared Touzer, the eastern hills took on their evening amethyst, with sapphire shadow, like a bit of the walls of the New Jerusalem let down, and the sun sank in a blaze of copper and mulberry purple, with the faintest baby new moon hung above it in the blue.

The Mighty One, God, the Lord, speaks and summons the earth from the rising of the sun to the place where it sets.

Psalm 50:1

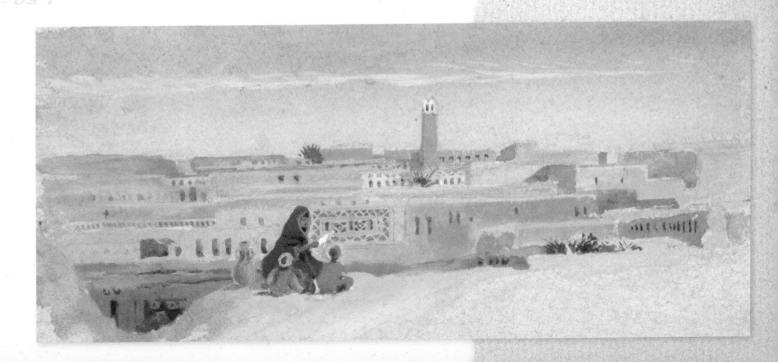

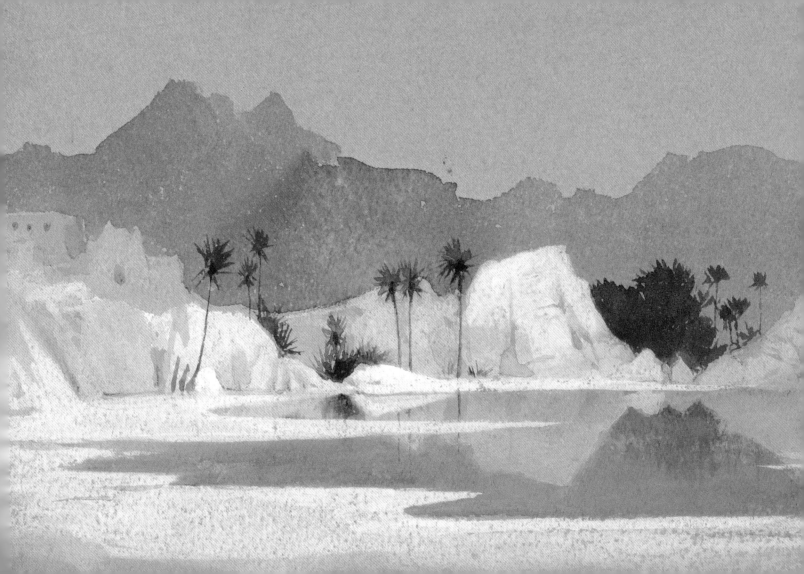

Riverbed

We were up and out early, and went down to the riverbed. Looking back, every crack and line of the hills lay reflected in a pool. Looking on and on, the desert stretched away like a great sea, broken only by an island of palms here and there, away and away to the Touaregs and the Sudan beyond. I shall never forget the feeling of that first sight of it. The sense of rest and silence that lies in the immensity of it grows day by day.

For you make me glad by your deeds, O Lord;
I sing for joy at the works of your hands.
How great are your works, O Lord,
how profound your thoughts!

Psalm 92:4–5

Life

Jesus said, "I am the gate; whoever enters through me will be saved."

John 10:9

Gateway to Life

Act or Process?

Is it an act, or a gradual process, this "putting off the old man"? It is both. It is a resolve taken once for all, but carried out in detail day by day. From the first hour that the layer of separation begins to form in the leaf-stalk, the leaf's fate is sealed: there is never a moment's reversal of the decision. Each day that follows is a steady carrying out of the plant purpose: "this old leaf shall die, and the new leaf shall live." So with your soul. Come to the decision once for all: "Every known sin shall go—if there is a deliverance to be had, I will have it." Put the Cross of Christ, in its mysterious delivering power, irrevocably between you and sinning, and hold on there. That is your part, and you must do it."

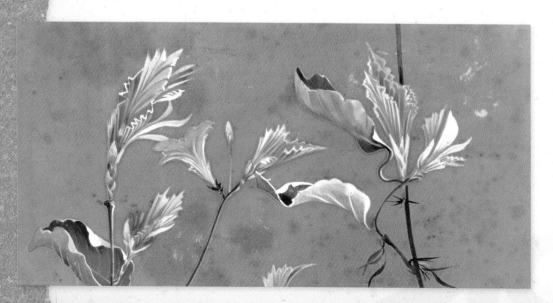

The death he died, he died to sin once for all; but the life he lives, he lives to God. In the same way, count yourselves dead to sin but alive to God in Christ Jesus.

Romans 6:10–11

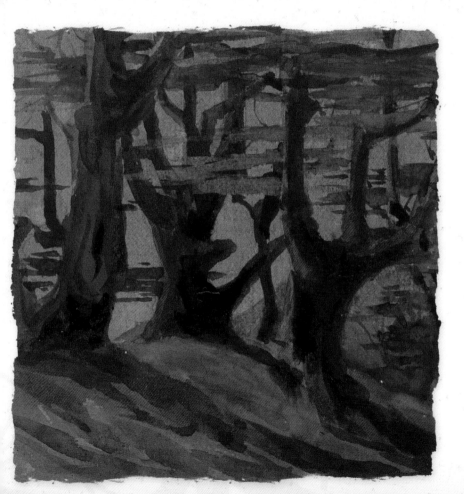

Joined at the Heart

It was an old fir-trunk on the edge of the little wood above the inn—and it was such a revelation of what it means to be a branch! I had always thought of branches as stuck in somehow through the bark! But this stump, decayed away to leaving the skeleton visible, shows how they are knit together into one heart in the center—the little slender thing no thicker than a pencil, which joins them all. Whereabouts they come through the bark matters little: It is the tiny channel that joins them into the living heart that is the point that matters.

If anyone is in Christ, he is a new creation; the old has gone, the new has come!

2 Corinthians 5:17

Parable of the Acorn

"Give me a death in which there shall be no life, and a life in which there shall be no death." That was a prayer of the Arab saint, Abed-El-Kader—I came upon it again the other day. Is it not wonderful?

And all nature here is full of such intense quietness these autumn days. A solemn quietness, with the sense of the spring behind it, like Easter Eve. The dear living things are going into their graves—and one sees how the grave is a must-be. "Fall into the ground and die"—not upon it. The road outside our lodging is strewn with acorns that will never come to anything because they are just lying on the ground, not in it.

Don't you know that all of us who were baptized into Christ Jesus were baptized into his death? We were therefore buried with him through baptism into death in order that, just as Christ was raised from the dead through the glory of the Father, we too may live a new life.

Romans 6:3–4

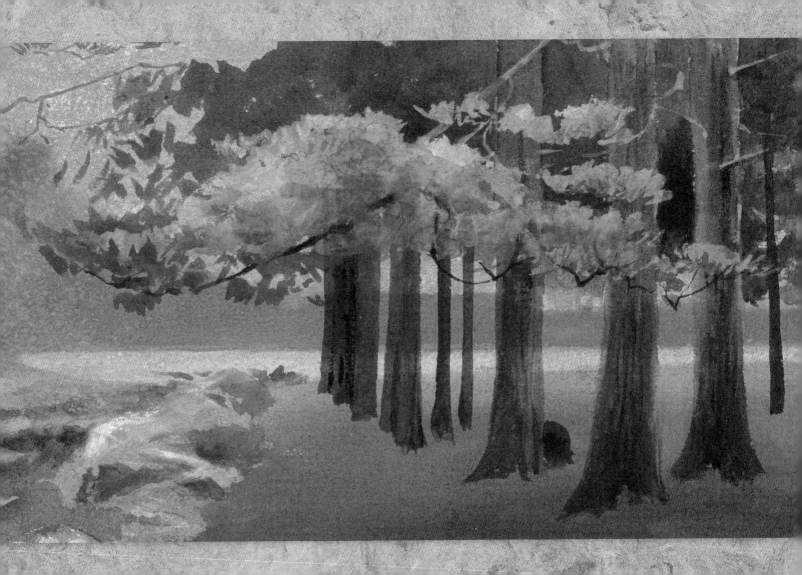

Parable of the Well Water

Such a lovely "beholding" today! I went to the well—and it was uncovered for me to look down. Instead of the still circle of water I expected to see, it was all heaving and rippling in swelling circles! Then it stopped and grew quiet, and while I was wondering if my eyes could have deceived me, the trembling began and all was repeated. Some periodic up-burst from the hidden spring below—then all grew glassy again. I never knew before what the "well of water springing up" meant. I thought of it vaguely as a springing all the time.

But this is so much more like His way with our souls. A sudden rising and flooding of the underlying life—and then a sinking back with stillness.

Jesus said, "Whoever drinks the water I give him will never thirst. Indeed, the water I give him will become in him a spring of water welling up to eternal life."

John 4:14

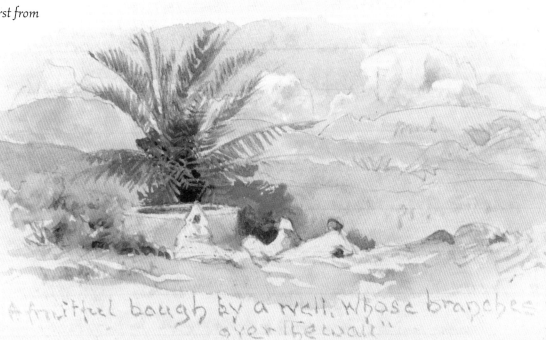

"A fruitful bough by a well, whose branches over the wall"

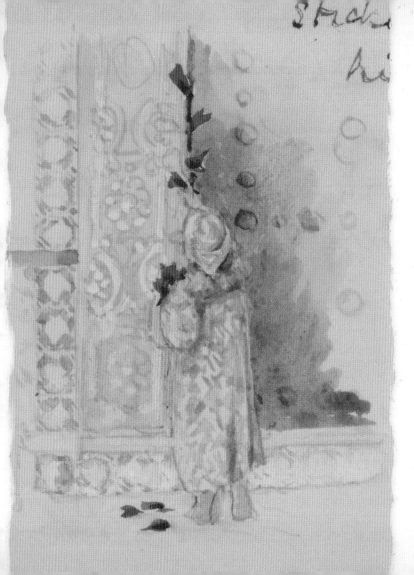

Stages of Heavenly Growth

You are right to be glad in His April days while He gives them. Every stage of the heavenly growth in us is lovely to Him; He is the God of the daisies and the lambs and the merry child hearts! It may be that no such path of loss lies before you; there are people like the lands where spring and summer weave the year between them, and the autumn processes are hardly noticed as they come and go. The one thing is to keep obedient in spirit, then you will be ready to let the flower-time pass if He bids you, when the sun of His love has worked some more ripening. You will feel by then that to try to keep the withering blossoms would be to cramp and ruin your soul. It is loss to keep when God says "give."

But grow in the grace and knowledge of our Lord and Savior Jesus Christ.

2 Peter 3:18

The Glory of His Gladness

Yes, life is the uppermost—resurrection life, radiant and joyful and strong—for we represent down here Him who liveth and was dead and is alive forevermore. Stress had to be laid on the death gateway, but a gateway is never a dwelling-place; the death-stage is never meant for our souls to stay and brood over, but to pass through with a will into the light beyond. We may and must, like the plants, bear its marks, but they should be visible to God rather than to man, for above all and through all is the inflowing, overflowing life of Jesus. Oh let us not dim it by a shadow of morbidness or of gloom: He is not a god of the dead, but a God of the living, and He would have us let the glory of His gladness shine out.

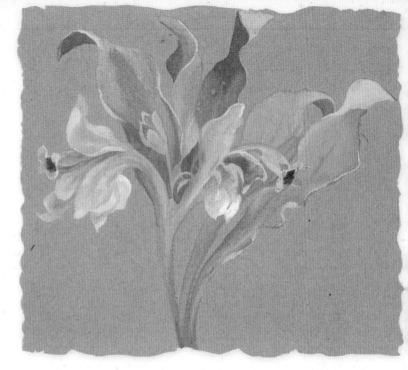

"I have come that they may have life, and have it to the full."

John 10:10

Growing Points

Growing points were the things that spoke to me on the journey through Italy. You can see them already on the bare boughs, waiting for the spring, and all the year through they are the most precious thing the plant has got, be it great or small, and the most shielded therefore, from chance of harm.

And the growing point of our soul is the thing with which the Spirit of God is specially dealing, and all depends on faithfulness there. If it is blighted by the chill of disobedience to His voice, He does not immediately begin to work again on some other point, but there is silence—like that long fourteen years silence in Abraham's life after he had gone off the lines of God's dealing in taking Hagar to wife. In grace God came to him again and took up the broken thread—but they were fourteen wasted years so far as we can see, so far as any fresh revelation of God goes. And our time left for growing is so short that we cannot afford to waste a day.

Be very careful, then, how you live—not as unwise but as wise, making the most of every opportunity, because the days are evil. Therefore do not be foolish, but understand what the Lord's will is.

Ephesians 4:15–17

So then, just as you received Christ Jesus as Lord, continue to live in him, rooted and built up in him, strengthened in the faith as you were taught, and overflowing with thankfulness.

Colossians 2:6–7

Life in Christ

Rivers of Living Water

The milky-looking glacier torrent spoke with God's voice this morning—so obedient to its course in its narrow bed, yet just tossing with freedom and swing in every motion. Such a picture of the "rivers of living water"—bound and yet unbound.

Jesus said, "Whoever believes in me, as the Scripture has said, streams of living water will flow from within him."

John 7:38

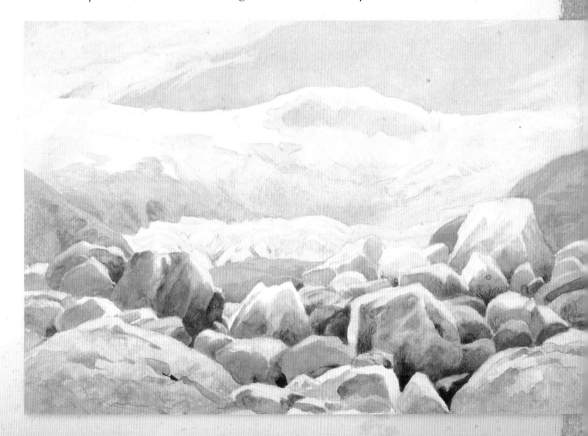

In the Way of His Steps

There came crashing down on my soul, in Daily Light, the verse "by Him actions are weighed," together with a lightning-flash that showed suddenly a letter I must write, that would be terrible pain to the one who received it. It seemed at the first moment almost an impossibility. But God's voice was unmistakable, and there was nothing for it but blind obedience, and after holding it before Him till next morning, the letter went off. (Needless to say it worked His work.) Usually the last thing on my mind would keep me awake nearly all night—but that night I slept like a child, and have done so ever since. All the nerve tension and exhaustion melted away then and there in the flood of new life that came—new Divine life I knew it to be, from the Fountain of Life Himself, renewing soul and body together. All the more wonderful from having come unsought— just "in the way of His Steps."

The Lord will guide you always;
he will satisfy your needs in a sun-scorched land
and will strengthen your frame.
You will be like a well-watered garden,
like a spring whose waters never fail.

Isaiah 58:11

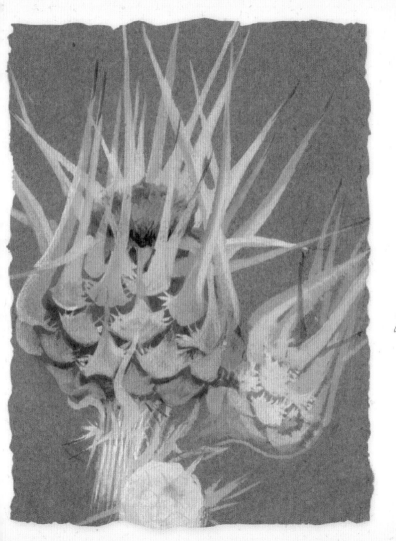

Parable of the Lost Blessing

Down to Blida again ... the country is beginning to look tawny and the summer blaze of thistles is beginning: spires of golden stars—the color of the yolk of an egg—side by side with the great indigo balls. But the thing that speaks to me most is the wide dry riverbed with its memory of waters that have ebbed away and its parable of lost blessing. It speaks of all the possibilities that have been "let slip"—having left only barren places behind.

Jesus said, "For everyone who has will be given more, and he will have an abundance. Whoever does not have, even what he has will be taken from him."

Matthew 25:29

Grand Simplicity

"I do this thing for God, not for success in the work, or for happiness in my soul or for anything else. I am here for God."

Life is grandly simple when the spirit of calculating results and consequences, even spiritual results and consequences, has been left among the things that are behind, when obedience is the one thing that matters, when God Himself, and no mere "experience," is our exceeding great reward.

Whatever you do, whether in word or deed, do it all in the name of the Lord Jesus, giving thanks to God the Father through him.

Colossian 3:17

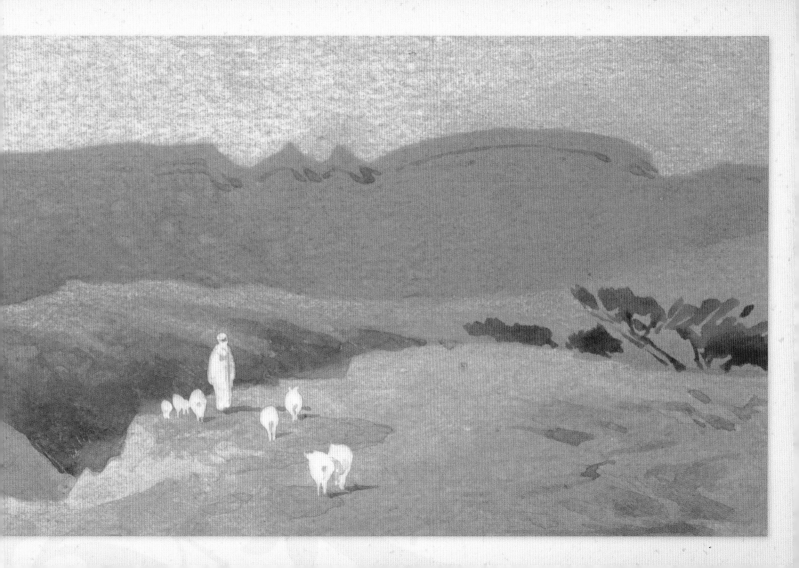

Focused Life

How do we bring things to a focus in the world of optics? Not by looking at the things to be dropped, but by looking at the one point that is to be brought out.

Turn full your soul's vision to Jesus, and look and look at Him, and a strange dimness will come over all that is apart from Him, and the Divine "attrait" by which God's saints are made, even in this 20th century, will lay hold of you. For "He is worthy" to have all there is to be had in the heart that He has died to win.

"Turn your eyes upon Jesus
Look full in His wonderful face;
And the things of earth will grow strangely dim
In the light of His glory and grace."

For to me, to live is Christ.

Philippians 1:21

Lesson of the Crab

I had a beautiful day alone at Pescade, in a fresh little cave that we had never found before. My sermon was from a little crab perched on a rock below, which matched his light-brown shell exactly. He was just as alive and just as happy whether basking in the air and sunlight—or buried (as took place about every other minute) under a foot or two of water as a wave swept over him. I could see him through the clear green-ness, quietly holding on below. There is no place where it is difficult for Jesus to live. His life in us can be just as adaptable as the life He has given to this tiny creature.

I can do everything through him who gives me strength.

Philippians 4:13

Parable of the Choked Well

I think the chief desert lesson of these last days has been a choked well that we passed yesterday. "Bounab is dead," they said. "You must add to your water-skins another." And yesterday we passed it—a masonried circle like the others, in a bare dry waste, but down below the surface it was choked up. A young camel had fallen down it last year, and they could not get him up, and in a day or two the well was poisoned beyond hope of restoration. There was nothing for it but to fill it in with stones and sand and leave it—a standing memory of lost possibilities.

"Of all sad words of tongue or pen
The saddest are these—it might have been."

God save us from any of the "other things entering in" that would make us dead wells in this world's wilderness.

Still others, like seed sown among thorns, hear the word; but the worries of this life, the deceitfulness of wealth and the desires for other things come in and choke the word, making it unfruitful.

Mark 4:18–19

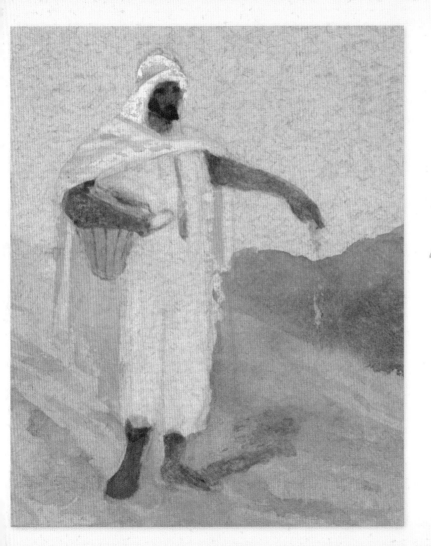

Goal of Maturity

A flower that stops short at its flowering misses its purpose. We were created for more than our own spiritual development; reproduction, not mere development, is the goal of matured being—reproduction in other lives.

Jesus said, "Go and make disciples of all nations, baptizing them in the name of the Father and of the Son and of the Holy Spirit, and teaching them to obey everything I have commanded you."

Matthew 28:19–20

If the Son sets you free, you will be free indeed.

John 8:36

Grand Independence of Soul

His Ideal Unhindered

Holiness, not safety, is the end of our calling.

Separation from all known sin is the starting-point for sanctification, not the goal: it is only the negative side of holiness; it is only reaching the place where God can develop His ideal in us unhindered. It is when the death of winter has done its work that the sun can draw out in each plant its own individuality, and make its existence full and fragrant. Holiness means something more than the sweeping away of the old leaves of sin: it means the life of Jesus developed in us.

What more do we need for our souls than to have this God for our God?

Put on the new self, created to be like God in true righteousness and holiness.

Ephesians 4:24

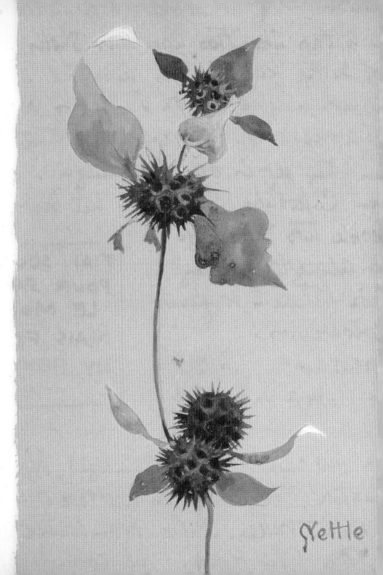

Nettle

Pure and Sweet

I had a time with Aissha alone. Her soul was clouded and I could get no response heavenward. She was preparing to go, winding her coarse white haik round her. I could only call silently on God for some touch. Then her eyes rested on a vase of flowers on the table— celandines from the lanes, and cream and gold jonquils from the fields. I said "How pure they are—that is the purity that God wants."

She looked up with her face soft and shining, "Yes, I should like the life of Jesus in me to be like that."

"Yes," I answered, "they came pure and sweet out of the black muddy earth, without a soil on them. Shall we pray that you may be like them?" Her head went down on my shoulder and "Amen" broke out as I prayed. May He grant it!

Create in me a pure heart, O God,
 and renew a steadfast spirit within me.

Psalm 51:10

A Quiet Heart

I was at Fehira's the other day. She was heavy and sorrowful. At last it came out that her husband had said some very insulting things about her and that they had been noised about and her good name blackened. "Did you answer him back?" I asked.

"Without doubt I did!" was the answer. So we read about Him who, when He was reviled, reviled not again, and she prayed, "Lord, make my tongue quiet."

Today I was there again and asked how things had been. Yes, her tongue had been kept quiet, she said, "but all is hot inside. The words stay in, because I asked God, but it is all hot." So we went a bit further on the road to holiness and she prayed, "Lord, Thou hast made my tongue quiet. Make my heart quiet now."

Let the peace of Christ rule in your hearts.

Colossians 3:15

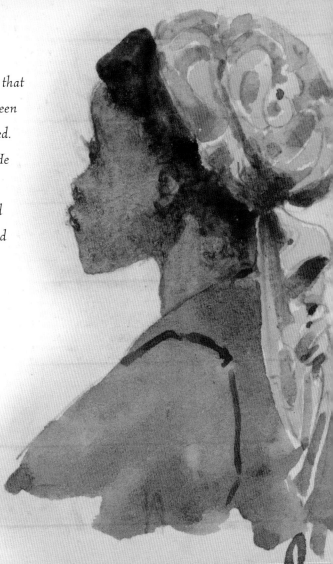

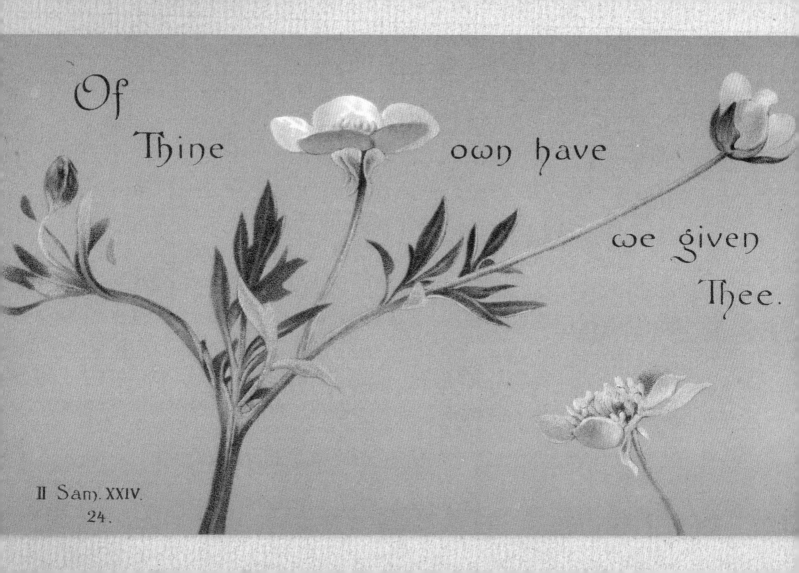

Of Thine own have we given Thee.

II Sam. XXIV. 24.

Lesson of the Buttercup

Look at this buttercup as it begins to learn its new lesson. The little hands of the calyx clasp tightly in the bud round the beautiful petals; in the young flower their grasp grows more elastic—loosening somewhat in the daytime, but keeping the power of contracting, able to close in again during a rainstorm, or when night comes on. But see the central flower, which has reached its maturity. The calyx hands have unclasped utterly now—they have folded themselves back, past all power of closing again upon the petals, leaving the golden crown free to float away when God's time comes.

Have we learned the buttercup's lesson yet? Are our hands off the very blossom of our life? Are all things—even the treasures that He has sanctified—held loosely, ready to be parted with, without a struggle, when He asks for them?

Everything comes from you, and we have given you
only what comes from your hand.

1 Chronicles 29:14

Place of Sacrifice

We have had an object lesson these days over our Tolga hen. She suddenly determined to sit—and sat on her one solitary egg a whole day. By evening she had plucked her breast bare to make a nest for it. So we got a "sitting" for her and arranged it in a native basket in the corner of the hen house and took her to see it. One moment she stood on the edge deliberating—then with such purpose of heart she just glided down onto the eggs and will hardly move even to eat. Such a consuming passion over those eggs has laid hold of her, and such a transformation they have wrought in the restless creature. The only thing that can get a cry out of her is if we try to get her away from her place of sacrifice.

Measure your life by loss, and not by gain,
Not by the wine drunk, but by the wine poured forth;
For love's strength standeth in love's sacrifice,
And he who suffers most has most to give.

Seek first his kingdom and his righteousness,
and all these things will be given to you as well.

Matthew 6:33

Subdued Unto Himself

God has opened up to me a whole new area that has to be "subdued unto Himself"—the whole region of natural temperament that lies at the back of the self-life in man and needs to be transformed by the renewing of our mind. Translated that does not mean annihilated, but transformed by a new mind and body. He can take that very susceptibleness that has been a snare and make it into a means of contact with Himself.

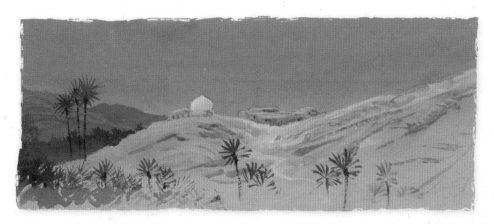

Therefore, I urge you, brothers, in view of God's mercy, to offer your bodies as living sacrifices, holy and pleasing to God—this is your spiritual act of worship. Do not conform any longer to the pattern of this world, but be transformed by the renewing of your mind. Then you will be able to test and approve what God's will is—his good, pleasing and perfect will.

Romans 12:1–2

Ready to Be Offered

This dandelion has long ago surrendered its golden petals and has reached its crowning stage of dying—
the delicate seed-globe must break up now—it gives and gives till it has nothing left…There is no sense
of wrenching: it stands ready, holding up its little life, not knowing when or where or how the wind that
bloweth where it listeth may carry it away. It holds itself no longer for its own keeping, only as something
to be given: a breath does the rest, turning the "readiness to will" into the "performance."

Now finish the work, so that your eager willingness to do it may be
matched by your completion of it, according to your means.

2 Corinthians 8:11

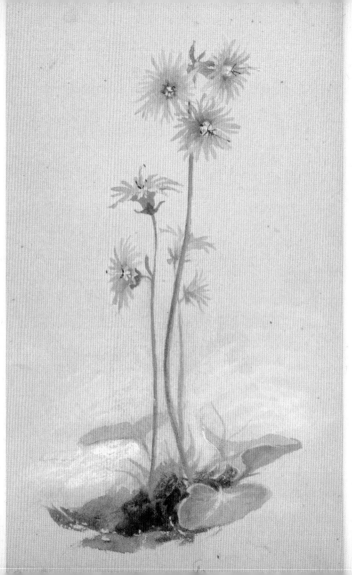

A Grand Independence of Soul

And a like independence is the characteristic of the new flood of resurrection life that comes to our souls as we learn this fresh lesson of dying—a grand independence of any earthly thing to satisfy our soul. The liberty of those who have nothing to lose because they have nothing to keep. We can do without anything while we have God.

I consider everything a loss compared to the surpassing greatness of knowing Christ Jesus.

Philippians 3:8

Your attitude should be the same as that of Christ Jesus: Who, being in very nature God, did not consider equality with God something to be grasped, but made himself nothing, taking the very nature of a servant.

Philippians 2:5–7

Humility

Life

Clouds of Rain

Things still look dark and heavy all round—but "when the clouds be full of rain they empty themselves upon the earth." It is better to wait, as the parched ground waits here, for the torrents that will set life going. I am beginning to see that it is out of a low place that one can best believe.

Wait for the Lord;
 be strong and take heart
 and wait for the Lord.

Psalm 27:14

Water of Life

We went up today to the Breitenboden valley behind us—up to the water courses where the snow breath keeps the gentians and the primulas and soldanellas awake still, through the hot August days . . . and then down by a little clear olive-green lake that gave birth to the stream by whose side we found our way down. That stream has been God's word to me. The rush of the water was marvellous. You could hardly hold a cup in it—and when one took it out, the water still whirled round and round in it for several seconds after. The

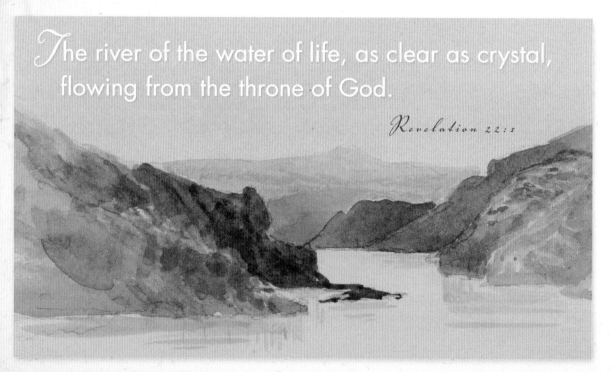

The river of the water of life, as clear as crystal, flowing from the throne of God.

Revelation 22:1

impetus came from having its source so high, and coming so swiftly down into low place. It has linked itself with the words, "Being by the right hand of God exalted . . . he hath shed forth this." If only Jesus is high enough and we are low enough, the stream of His Spirit must be mighty.

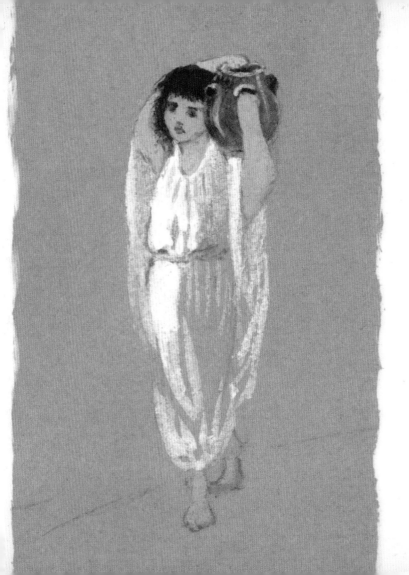

Low Enough

The Blida well, which has always a curious linking with the eternal springs in our minds, has taken on a fresh phase. The old complicated machinery has got completely wrecked by native handling, and now they find they can get a pail of clear cold water every two minutes with a cord and wheel and two buckets! It has been a fresh means of [seeing] grace on the spiritual side, in the absolute simplicity of the thing. We hamper ourselves with spiritual machinery of a complex link in the ways of "experiences" and how to reach them, when all we need is to "become as little children," so to speak, with a bucket and a cord. Willing just to go down and down and down till the Living Water closes round our souls and fills them. [To be] "filled full in Him," it only needs to go low enough.

All my fountains are in you.

Psalm 87:7

Depths of Nothingness

One grew to see a little how one could have a ministry precious in God's eyes even when all was toughest. Ezekiel was the most spirit-filled of all the prophets and yet he was sent to a house "impudent and hard-hearted" to speak "whether they would hear or whether they would forbear." That is enough to silence all questionings on that subject—only the filling needed for it involves, as his did, a deep baptism into death—an abandonment down into the depths of nothingness. Oh, we take a time to get there!

Serve wholeheartedly, as if you were serving the Lord, not men, because you know that the Lord will reward everyone for whatever good he does.

Ephesians 6:7–8

Inadequacy and Inefficiency

The same lesson is reiterated all round by God: the simple ABC lesson that inadequacy and inefficiency on the human side are His conditions for working. "He sealeth up the hand of every man, that all men may know His work."

Therefore I will boast all the more gladly about my weaknesses, so that Christ's power may rest on me.

2 Corinthians 12:9

Parable of the Trolleys

The trolleys have been reading me a lesson these last days as they run up and down the moorsides with their loads of granite from the quarries above. The full ones go down—down—that the empty ones may be drawn up. It is the same as with the seeds. "Death worketh in us, but life in you." Down, down, we must go.

"Faith is the link which joins our uttermost weakness to God's almighty strength." I came on that the other day, and it is so true. Faith that comes from the depths has a spring in it, like the water pressed down into a low narrow channel that can rise into a fountain.

I will make rivers flow on barren heights,
and springs within the valleys.
I will turn the desert into pools of water,
and the parched ground into springs.

Isaiah 41:18

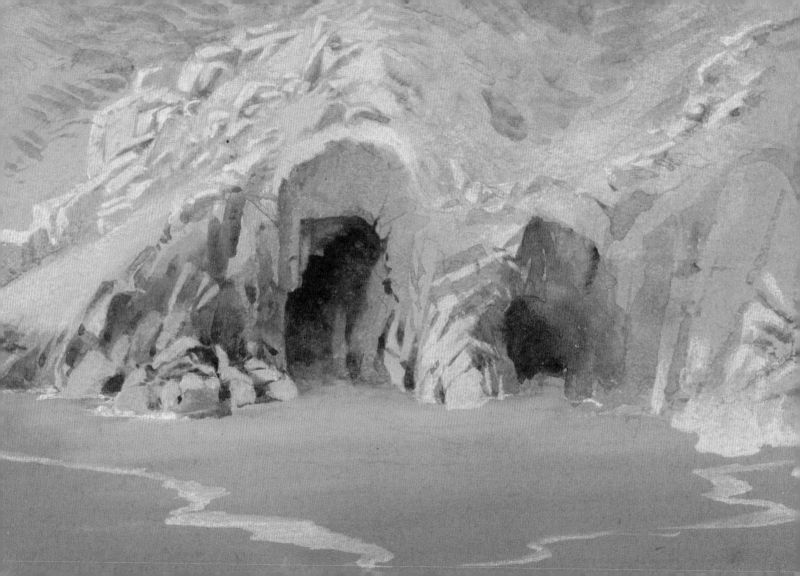

Weak with Him

Once more, after twenty-two years, Christmas Day in Tolga—and again Christmas-like in its deepest sense with just a touch of the fondouk [inn] to make it beautiful. Common brick walls, earth floor, unglazed windows—such a tiny touch, but fitting in with the wonderful sense of being "weak with Him," which is the key note to the beginnings here. "Wrapped in swaddling clothes, lying in a manger"—that is how the world's redemption dawned!

For you know the grace of our Lord Jesus Christ, that though he was rich, yet for your sakes he became poor, so that you through his poverty might become rich.

2 Corinthians 8:9

Casting on God

We cast the whole thing on God and settled with one consent that we would believe in Him to use the very weakness of it and keep us all intent on showing not what we had done, but what we had not done. We gave into His Hands, too, the matter of the time-limit. If a day were with Him as a thousand years, He could make much of an hour.

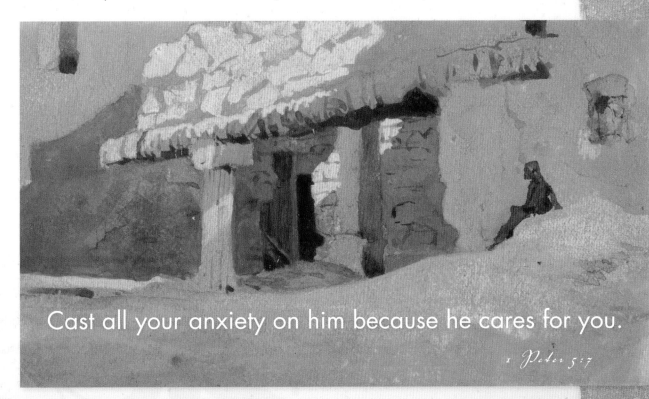

Cast all your anxiety on him because he cares for you.

1 Peter 5:7

Submit to the Father of our spirits and live!

Hebrews 12:9

Difficulty

Life

Passing Through

The word God has given is "passing through." Passing "through" the broken-up gate (Micah). Passing "through" the stoning crowd (Luke). Passing "through" the wall of waves (Hebrews 11). "By faith they passed through"— not on one side, avoiding the place of difficulty, but through.

When you pass through the waters, I will be with you; and when you pass through the rivers, they will not sweep over you. When you walk through the fire, you will not be burned; the flames will not set you ablaze.

Isaiah 43:2

> The eternal God is your refuge, and underneath are the everlasting arms.
>
> *Deuteronomy 33:27*

Deep Waters

"I am come into deep waters" took on a new meaning this morning. It started with perplexing matters concerning the future. Then it dawned that shallow waters were a place where you can neither sink nor swim, but in deep waters it is one or the other: "waters to swim in"—not to float in. Swimming is the intense, most strenuous form of motion—all of you is involved in it—and every inch of you is in abandonment of rest upon the water that bears you up.

"We rest in Thee, and in Thy Name we go."

Soul into Blossom

Take the very hardest thing in your life—the place of difficulty, outward or inward, and expect God to triumph gloriously in that very spot. Just there He can bring your soul into blossom!

In this you greatly rejoice, though now for a little while you may have had to suffer grief in all kinds of trials. These have come so that your faith—of greater worth than gold, which perishes even though refined by fire—may be proved genuine and may result in praise, glory and honor when Jesus Christ is revealed.

1 Peter 1:6–7

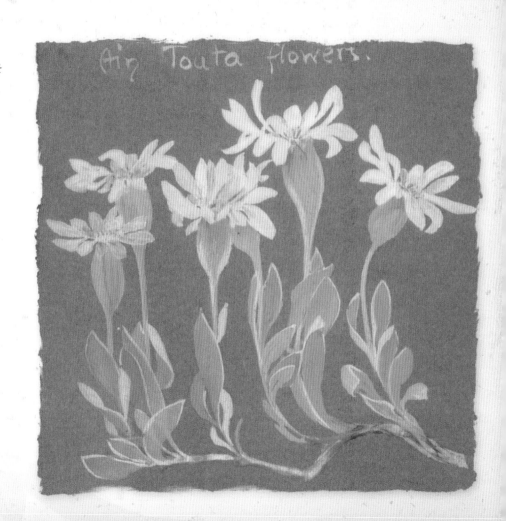

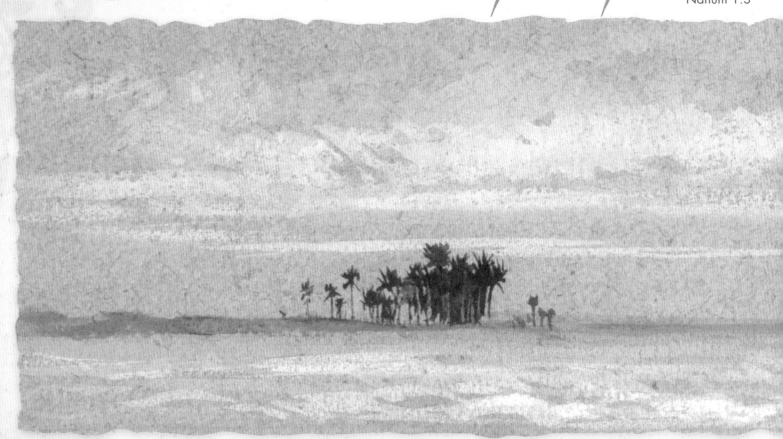

The clouds are the dust of His feet.

Nahum 1:3

Dust of His Feet

The beauty of that old line of Hebrew poetry came afresh today. The thickest of the cloud storm would be just where He is passing. We see the dust now. We shall see His Footprints when He has passed along the way.

The Lord replied, "My Presence will go with you, and I will give you rest."

Exodus 33:14

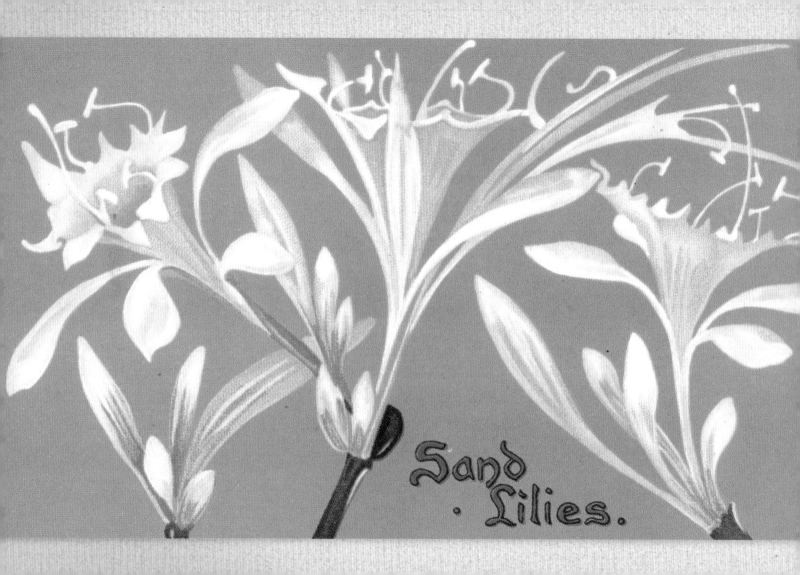

Sand
· Lilies.

Wild Lilies

Today's find was beautiful to the inward vision as well as to the outward. It was clusters of exquisite wild lilies—white and fragile and fragrant—growing out of the hot salt sand that drifts into dunes round the stunted juniper and lentisk bushes that fringe the shore. Down below the surface, the storage of reserve material in the lily bulbs had silently taken place … and there they had lain, shrouded and waiting. The hour had come now, and no adverse condition could keep back the upspringing. The same Lord over all can store the roots in His spiritual creation, even though they have but smothering sand drifts around them.

I pray that out of his glorious riches he may strengthen you with power through his Spirit in your inner being.

Ephesians 3:16

Parable of the Dew Drop

He maketh small the drops of "water." I have never seen how literally true that is till I began studying the dew these mornings. Let a drop fall from your finger and you will see its natural size. But that would be too heavy for the frail little blades to bear. It would slip off them from its weight. So He weighs out to each the tiny measure that it can bear without even being bowed down, yet enough to "drink into" in abundance. On one wee filament of moss I counted through a magnifying glass forty-six little globes of water in what just looked like moisture to the naked eye.

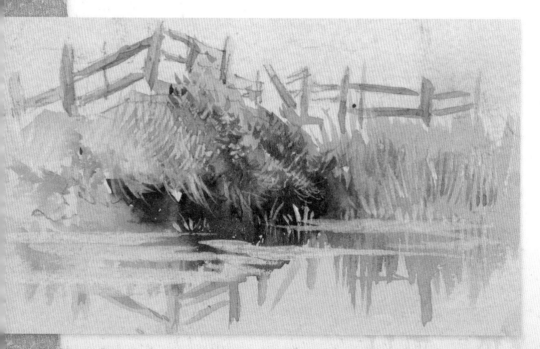

For our light and momentary troubles are achieving for us an eternal glory that far outweighs them all.

2 Corinthians 4:17

The Highest Music

All the more beautiful will be God's triumph when it comes. The highest music is not the music where all goes on simple and straight and sweet, but where discord suddenly resolves tensions with harmony.

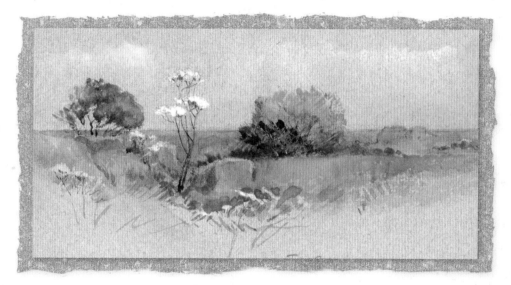

Blessed is the man who perseveres under trial, because when he has stood the test, he will receive the crown of life that God has promised to those who love him.

James 1:12

Mountains of Difficulty

"I will turn all my mountains into roads."..."The voice of my Beloved! Behold He cometh leaping upon the mountains, skipping upon the hills. My beloved is like a roe or a young hart." Those two verses have come to me with fresh light and power this morning, with regard to these fresh mountains of difficulty that have been heaved up.

We were noticing, as we came down into the Taberkatchent valley, how the mules who had stepped with absolute surefootedness on the steep difficult tracks—often on a double slope, downward and outwards towards the edge—stumbled along the government road below. It was because creatures of the mountain are so at home in difficult places that they are the easiest of any to them. Praise God that our Beloved finds difficulties the most natural places to act in and the easiest way of approach to our souls.

~

The Sovereign Lord is my strength;
he makes my feet like the feet of a deer,
he enables me to go on the heights.

Habakkuk 3:19

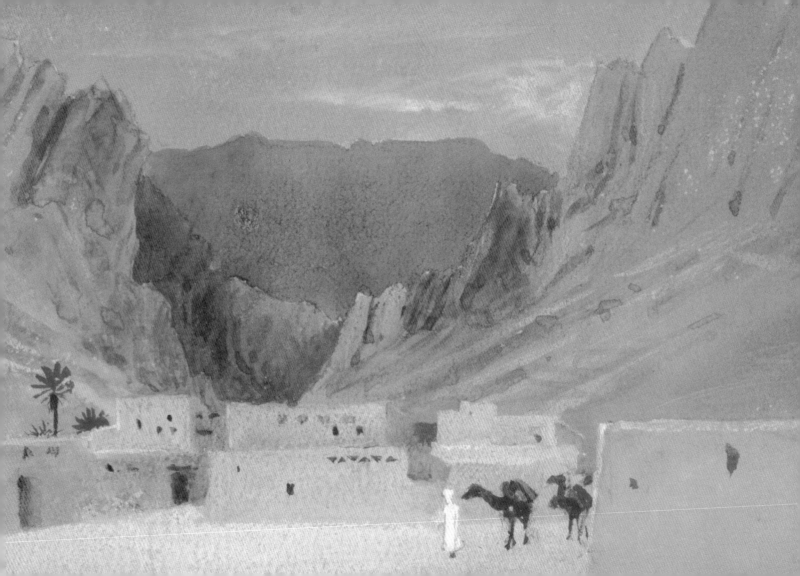

For nothing is impossible with God.

Luke 1:37

Glory of the Impossible

Life

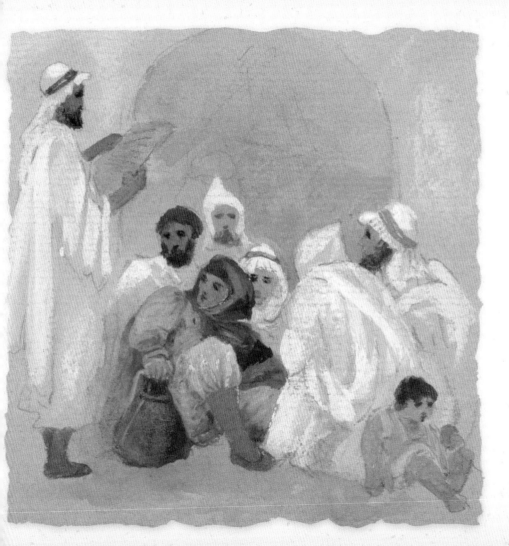

Impossible with Man

The things that are impossible with men are possible with God. May it not be that the human impossibility is just the very thing that set His Hand free? And that it is the things which are possible for us to do that He is in a measure to let alone?

Now to him who is able to do immeasurably more than all we ask or imagine, according to his power that is at work within us, to him be glory in the church and in Christ Jesus throughout all generations, for ever and ever!

Ephesians 3:20–21

Come and see what God has done,
how awesome his works in man's behalf!

Psalm 66:5

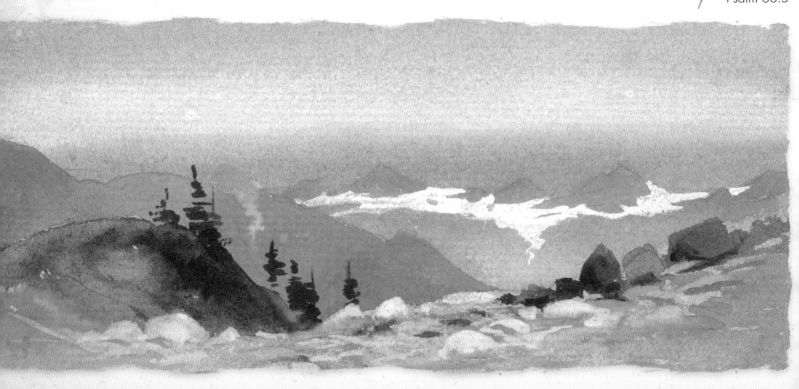

Glory of the Impossible

Far up in the Alpine hollows, year by year, God works one of His marvels. The snow patches lie there, frozen into ice at their edges from the strife of sunny days and frosty nights; and through that ice-crust come unscathed flowers in full bloom.

Back in the days of the bygone summer, the little soldanella plant spread its leaves wide and flat on the ground to drink in the sun-rays, and it kept them stored in the root through the winter. Then spring came and stirred its pulses even below the snow-shroud. And as it sprouted, warmth was given out in such a strange measure that it thawed a little dome in the snow above its head. Higher and higher it grew, and always above it rose the bell of air, till the flowerbud formed safely within it; and at last the icy covering of the air-bell gave way and let the blossom through into the sunshine, the crystalline texture of its mauve petals sparkling like the snow itself, as if it bore the traces of the fight through which it had come.

And the fragile thing rings an echo in our hearts that none of the jewel-like flowers nestled in the warm turf on the slopes below could waken. We love to see the impossible done. And so does God.

The Divine Exchange

The miracle of Cana has been shining out these days. "Fill the waterpots with water" has been their watchword. Undiluted weakness transmuted with undiluted strength. It seems to me as if the first thing we expect of God is that He will tinge our water with the wine of His power. Then as we progress in our faith understanding we look for its wine, but feel it must still have an admixture of our water. It is but slowly that we come to see that the mingling is not His way with us. It is "all weakness"—up to the brim—exchanged for His "all power."

Therefore I will boast all the more gladly about my weaknesses, so that Christ's power may rest on me.

2 Corinthians 12:9

Let Faith Swing Out

"The things that are impossible with men are possible with God." Yes, face it out to the end. Cast away every shadow of hope on the human side as a positive hindrance to the Divine; heap the difficulties together recklessly, and pile on as many more as you can find: you cannot get beyond that blessed climax of impossibility. Let faith swing out on Him. He is the God of the impossible.

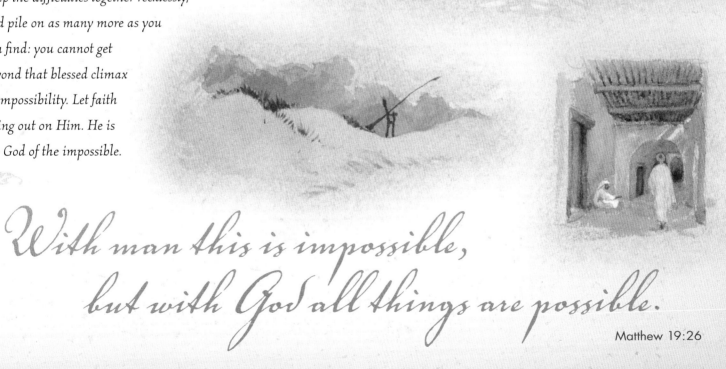

With man this is impossible, but with God all things are possible.

Matthew 19:26

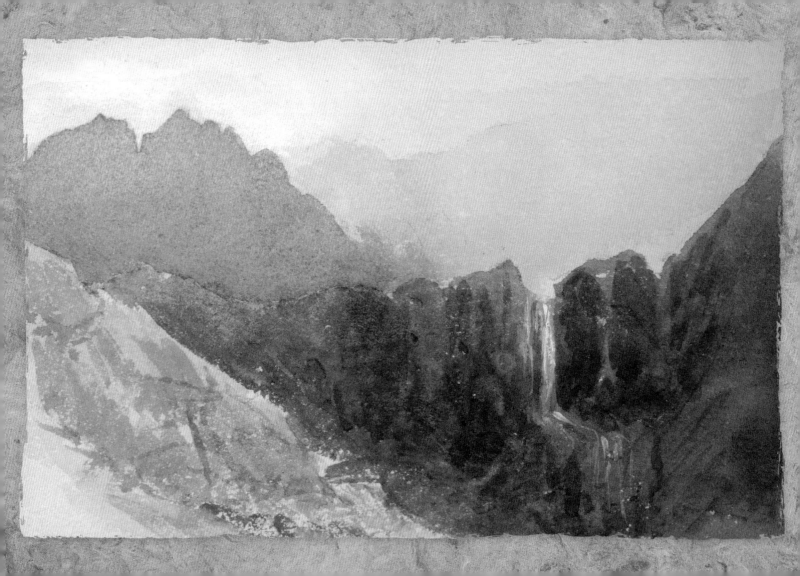

The Measure of Power

An old truth has come to me with vividness this morning in "the effectual working of His Power." All power is measured by what it affects, not by the sensations of the medium by which it works. The mightiest engines that man has made would only know of the consciousness that they were yielding, without a jar, to the inrush of the steam or the current of the electricity. The sweep of the planets only would mean to their experience that they were obeying laws. Neither medium nor the power would be conscious of anything but perfect rest and ease of motion. The ease of strain means increase, not loss, of power.

I pray also that the eyes of your heart may be enlightened in order that you may know the hope to which he has called you, the riches of his glorious inheritance in the saints, and his incomparably great power for us who believe. That power is like the working of his mighty strength.

Ephesians 1:18–19

The Price of Power

"Two glad Services are ours,
 Both the Master loves to bless:
 First we serve with all our powers
 Then with all our helplessness."

 Those lines of Charles Fox have rung in my head this last fortnight—and they link on with the wonderful words "weak with Him." For the world's salvation was not wrought out by the three years in which He went about doing good, but in the three hours of darkness in which He hung, stripped and nailed, in uttermost exhaustion of spirit, soul, and body—till His heart broke.

 So little wonder for us if the price of power is weakness.

For to be sure, he was crucified in weakness, yet he lives by God's power. Likewise, we are weak in him, yet by God's power we will live with him to serve you.

2 Corinthians 13:4

God's Power

"That the excellency of the power may be of God, and not of us."

Conscious weakness as a preparation for service is one thing; brokenness is another. We may know that we are but earthen pitchers, like Gideon's, with nothing of our own but the light within, and yet we may not have passed through the shattering that sheds the light forth. This does not mean something vague or imaginary, but intensely practical.

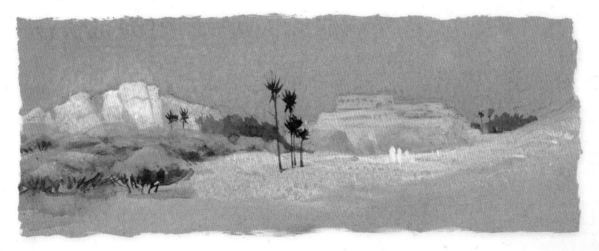

We have this treasure in jars of clay to show that this all-surpassing power is from God and not from us.

2 Corinthians 4:7

Love

For I am convinced that neither death nor life, neither angels nor demons, neither the present nor the future, nor any powers, neither height nor depth, nor anything else in all creation, will be able to separate us from the love of God that is in Christ Jesus our Lord.

Romans 8:38–39

The Poetry of God's Ways

Wings of the Morning

If I rise on the wings of the dawn,
if I settle on the far side of the sea,
even there your hand will guide me,
your right hand will hold me fast.

Psalm 139:9—10

*We have to do with a God to whom time is as boundless
as space in its elasticity!*

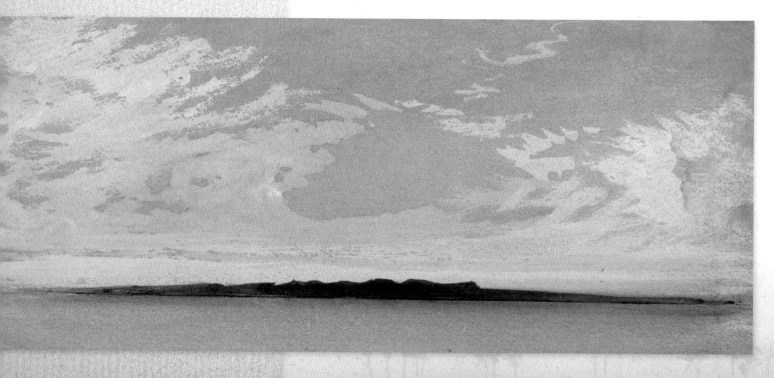

Closed Window, Open Door

In all the outward withholdings of this year, God, as is His wont, has been "opening" a door where He closes a window.

What he opens no one
can shut, and what he
shuts no one can open.

Revelation 3:7

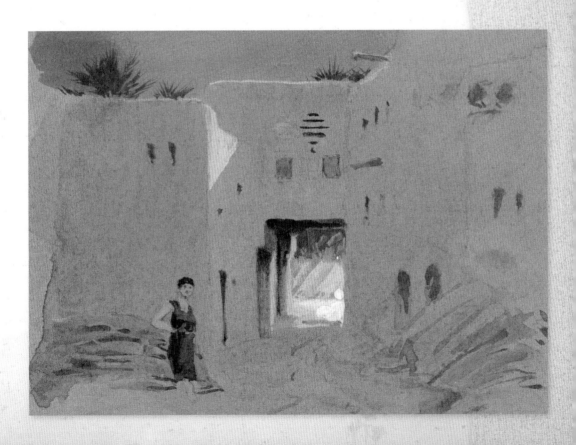

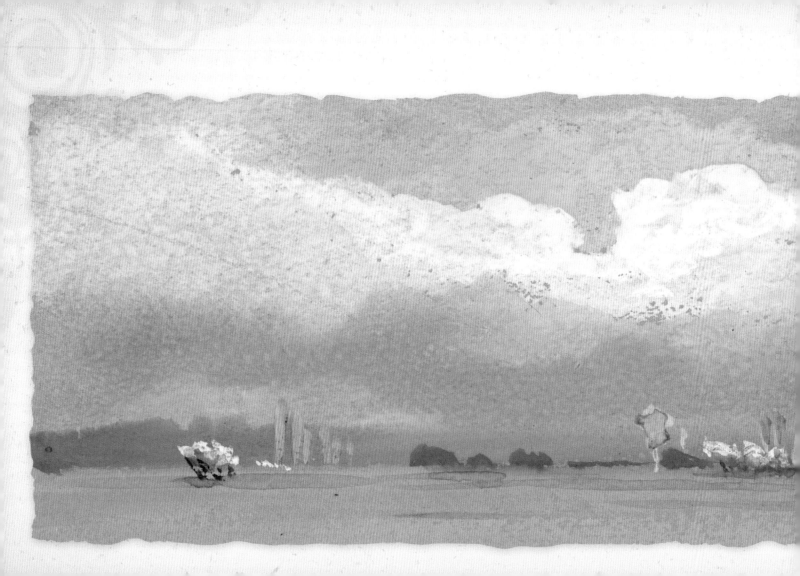

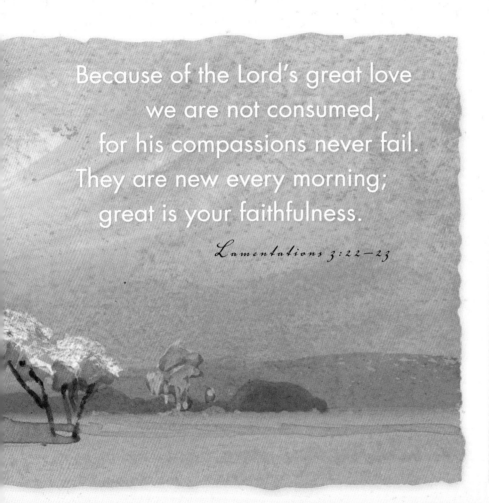

Because of the Lord's great love
we are not consumed,
for his compassions never fail.
They are new every morning;
great is your faithfulness.

Lamentations 3:22–23

Not Bound to Repeat

If it were only a matter of asking Him to repeat the miracles of the past, faith would have plenty of room. But He is not bound to reproduce. He is the Creator—have we ever let our hearts and hopes go out to the glory of that Name? Look at the tiny measure of creative power given to man, in music, poetry, art—where there is a spark of it, how it refuses to be fettered by repeating itself. The history of His wonders in the past is a constant succession of new things, and He is not at the end of His resources yet.

Thy Will Be Done

"Thy will be done" not in passive acquiescence but in victorious might.

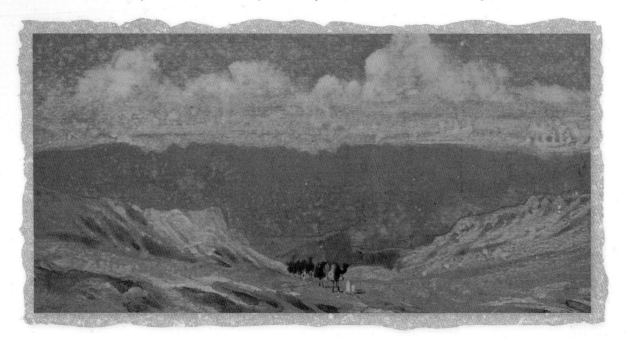

It is God who works in you to will and to act according to his good purpose.

Philippians 2:13

The Rest of His Steps

There is a great sense of rest in being in the way of His steps.

Jesus said, "Come to me, all you who are weary and burdened, and I will give you rest. Take my yoke upon you and learn from me, for I am gentle and humble in heart, and you will find rest for your souls. For my yoke is easy and my burden is light."

Matthew 11:28–30

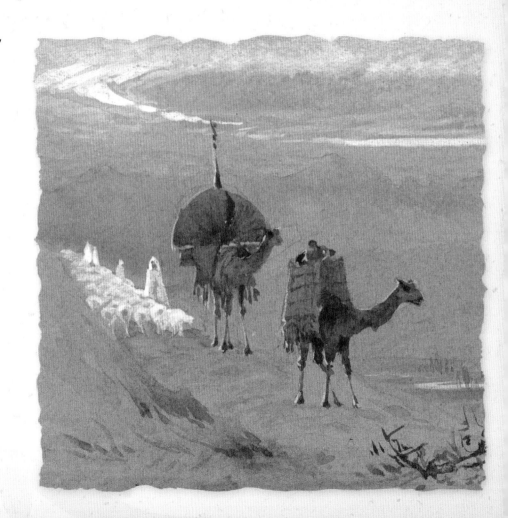

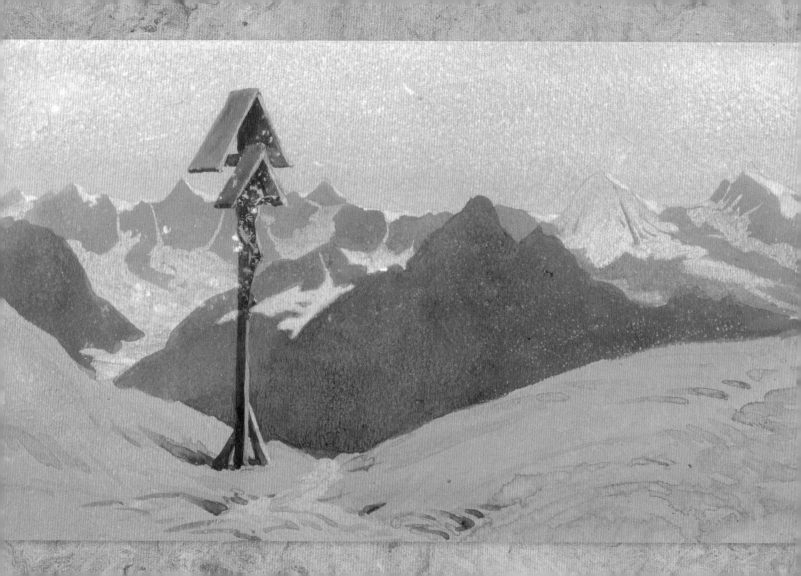

The Tracing of God's Way

All these things are so wonderful to watch—all the more wonderful from the watching being from a quiet room full of flowers, instead of from the din and dust of the battlefield, good though that was when God gave it. Only now it is easier to trace the working out of these "parts of His ways" and to almost see the still-unrevealed thought that links them.

Oh, the depth of the riches of the wisdom and knowledge of God!
How unsearchable his judgments, and his paths beyond tracing out!

Romans 11:33

Be still, and know that I am God.

Psalm 46:10

Alone with God

Waiting on God

I have never seen Switzerland look so gloriously happy as it does this year.

Then shall Thy smile discover many things
Why laugh the hearts of children at their play
Why skip the lambs and why the skylark sings.

The peaks of the Mischabel were just shouting for joy this morning in radiant snow, after a day's storm, and the last filaments of cloud were dancing round their crests. Oh it is a wonderful world.

The Findeln lessons have been going on. The lessons of a need of unrestrained waiting on God. Waiting with all the "pull" taken out of it arrests the "other things" that we are leaving unsought so as to seek Him.

\mathcal{W}ait for the Lord;
be strong and take heart
and wait for the Lord.

Psalm 27:14

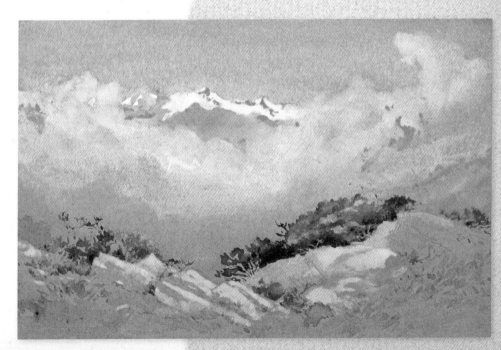

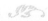

Daisies Talking

The daisies have been talking again—the girls brought in a clump the other day from their Saturday afternoon hours in the country. Somewhere long ago I saw that the reason they spread out their leaves flat on the ground—so flat that the scythe does not touch them—is because the flowers stretch out their little hands, as it were, to keep back the blades of grass that would shut out the sunlight. They speak so of the need of deliberately holding back everything that would crowd our souls and stifle the freedom of God's light and air.

The Lord is my portion; therefore I will wait for him.

Lamentations 3:24

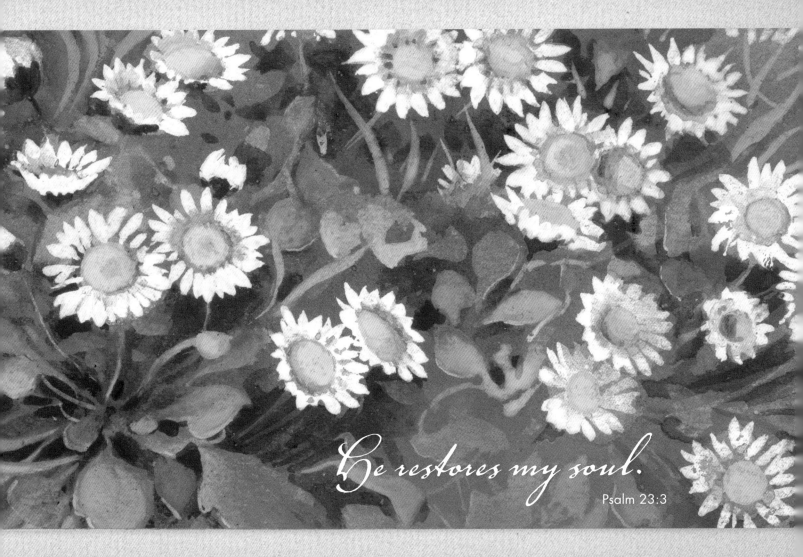

He restores my soul.

Psalm 23:3

Fortification Woods

I have found a corner in the Fortification Woods, only five minutes from the house, where one is quite shut in out of sight, and might be miles from a town but for the sound of the soldiers bugling on the height above. I go there nearly every morning with my Bible from 7:15 till 8:30. It is so delicious on these hot spring mornings, and God rests one through it for the whole day, and speaks so through all living things. Day after day something comes afresh.

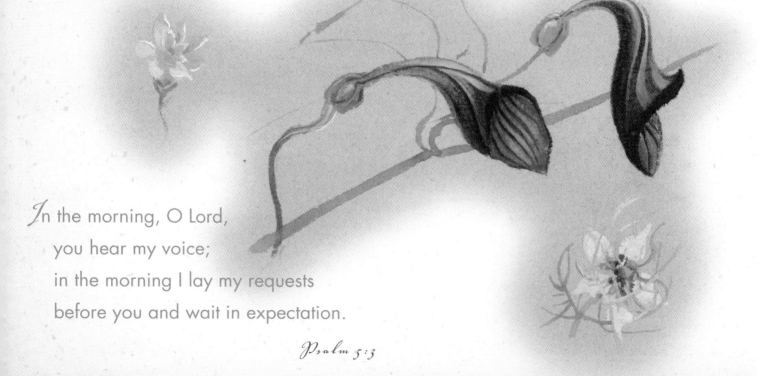

In the morning, O Lord,
 you hear my voice;
 in the morning I lay my requests
 before you and wait in expectation.

Psalm 5:3

Simple Beholding

If every fraction of a second tells in the film in the camera, while "unveiled" it faces the light, must not something of the same unseen work go on upon our spirits in every moment of unveiling before the Lord? When Moses went in before the Lord to speak with Him, he took the veil off. Bare absolute contact with God's Presence—if our times alone with Him were but that all the time, they would be mighty in their outcome.

And we, who with unveiled faces all reflect the Lord's glory, are being transformed into his likeness with ever-increasing glory, which comes from the Lord, who is the Spirit.

2 Corinthians 3:18

Desert Teaching

Today came the joy of setting our faces due south again, after all these years of waiting. It was lovely to see the base of the northern hills cut off, as we steamed slowly over the highest level of the plateau. Then came the plunge down into the basin of El Kantara, with its blue-green sea of palms and dear sundried brick houses. And then the desert hills took on their pink and blue afternoon lights and shadows. One moment's glory of sunset flashed out between the showers, after we got in, shading the desert from the mauve of the distant hills to the flame color of the cliffs of the river-bed in the foreground—a chord of color that is simply unpaintable and indescribable and unimaginable.

Oh, the desert is lovely in its restfulness. The great brooding stillness over and through everything is so full of God. One does not wonder that He used to take His people out into the wilderness to teach them.

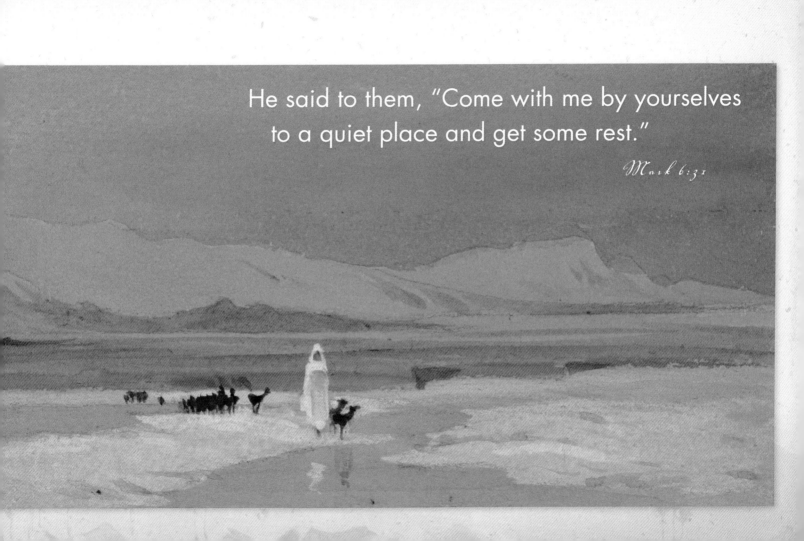

He said to them, "Come with me by yourselves to a quiet place and get some rest."

Mark 6:31

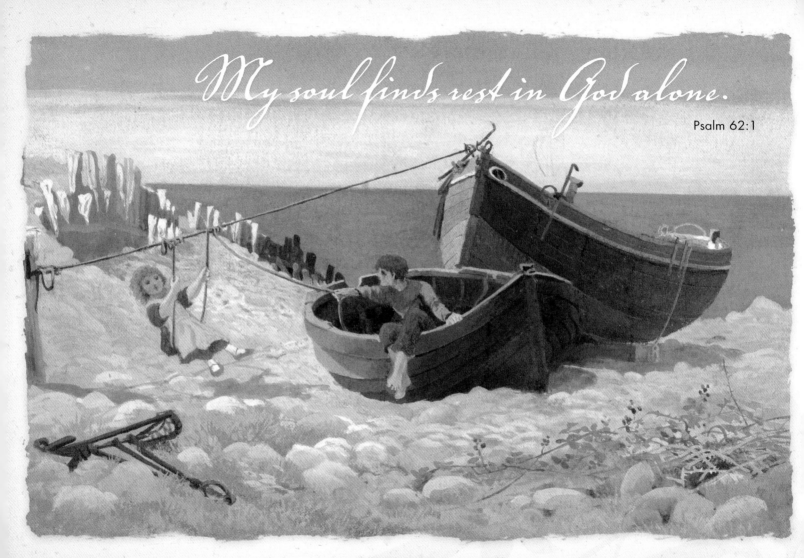

My soul finds rest in God alone.

Psalm 62:1

Alone with God

Oh the joy of being here again. Cornwall has the most wonderful "attrait" of any place I know on earth—except perhaps the desert. And there is a likeness, too, in all their unlikeness—the huge illimitableness of everything—one's whole being can expand.

And then the joy of a fortnight alone crowns it all—oh it is a gift from God. I nearly cried for joy when I got out among the heather on the cliff. Oh such places there are—far more wonderful than I remember even. Today I sat for hours among the boulders on the slope of the cliff of a little bay, looking across to the golden brown cliffs opposite, with one huge cavern like a cathedral door. The sea below every shade of emerald and sapphire and lapis lazuli, with deep purple shadow where the seaweed- covered rocks showed through. And above the till of moor, tawny turf and amethyst heather, broken with the grey-green of the rocks—and a strip of quiet sky above looking down on it all.

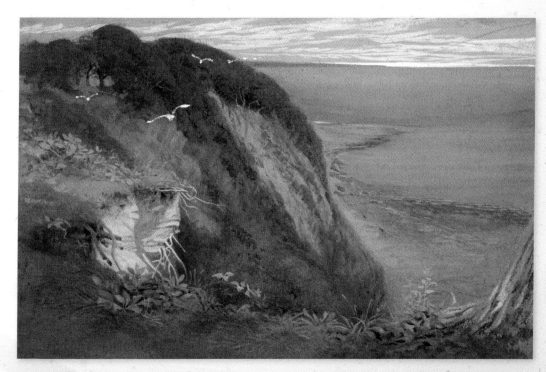

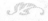

The Lord will guide you always;
 he will satisfy your needs in a sun-scorched land
 and will strengthen your frame.
You will be like a well-watered garden,
 like a spring whose waters never fail.

Isaiah 58:11

A Bit of Quiet

We felt that we must get our bit of quiet in
the garden today, for soul as well as body—
yesterday there was scarcely leisure "so
much as to eat." He makes the scraps
of aloneness very very precious—
and though there is no
possibility of having a key
or of ensuring the quiet
lasting for a moment,
one gets a sense
among the palms and
fruit blossoms that one
has so far as possible
shut the door. And it
is true as of old that
"the doors being shut,
came Jesus."

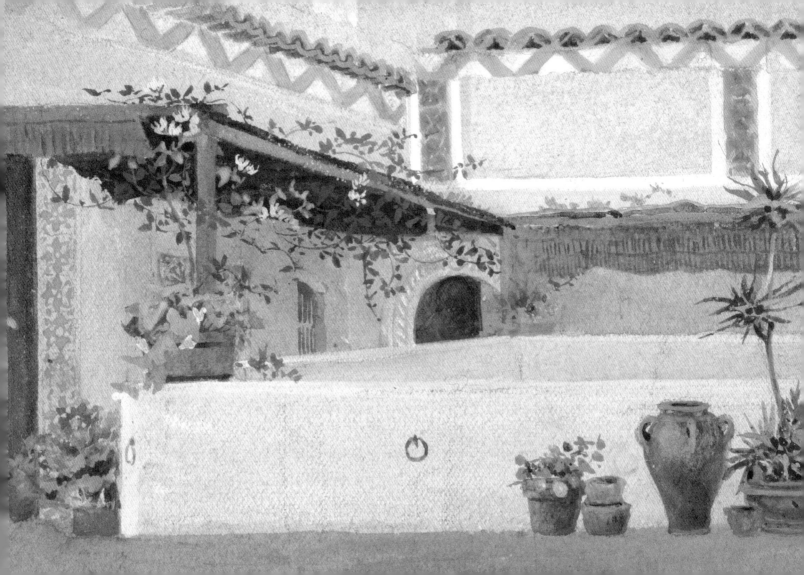

Refuge

It was lovely getting back to Algiers with all the welcoming that was waiting. They had been hard at it with workmen the last days, preparing surprises—two new windows knocked out in two ill-ventilated rooms; a much-needed verandah of native reed matting on the roof, leading up to a study, since disused, now filled up with mats and a low seat round the dais as a place where "prayer is wont to be made." It is so beautifully out of the way of all the sounds of the house—and it is a rule that no one is to be disturbed there. The "melja" we call it—Arabic for "refuge."

God is our refuge and strength, an ever-present help in trouble.

Psalm 46:1

The Lord is good to those whose hope is in him,
to the one who seeks him;
it is good to wait quietly
for the salvation of the Lord.

Lamentations 3:25–26

God's Time

Love

They That Wait

It was a narrow strip of valley, with a distant view of the Breithorn at the end, and lovely firwoods to sit in—and lovelier wreathings of clouds round the crags overhead. All day long they were twisting in and out of the little gullies with one river of blue sky between, just overhead, wreathing really round the feet of giant mountain—unseen above till one got on to the first ledges of rock at either side.

All was wrapped in clouds at first, and we could do nothing but watch for glimpses of the Matterhorn. At last, by moonlight, he came out from head to foot when the last shimmer of cloud drifted away. I don't think I shall ever forget the "watching for the morning" the next day—with the whole amphitheater of snow standing in dead white against the dim blue sky. It came as such a parable of waiting for the sunrise that is coming. To miss the first touch of rose-color is to miss the whole: "Blessed are all they that wait for Him."

Blessed are all who wait for him!

Isaiah 30:18

With the Lord a day is like a thousand years, and a thousand years are like a day. The Lord is not slow in keeping his promise, as some understand slowness.

2 Peter 3:8–9

God of Eternity

We are proving these days that time is nothing to God: nothing in its speeding, nothing in its halting. He is the God that "inhabiteth eternity."

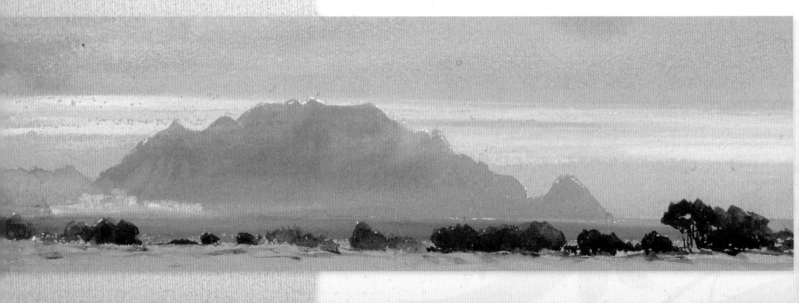

God's Delays

I am full of hope that when God delays in fulfilling our little thoughts, it is to have Himself room to work out His great ones.

"I know the plans I have for you," declares the Lord, "plans to prosper you and not to harm you, plans to give you hope and a future."

Jeremiah 29:11

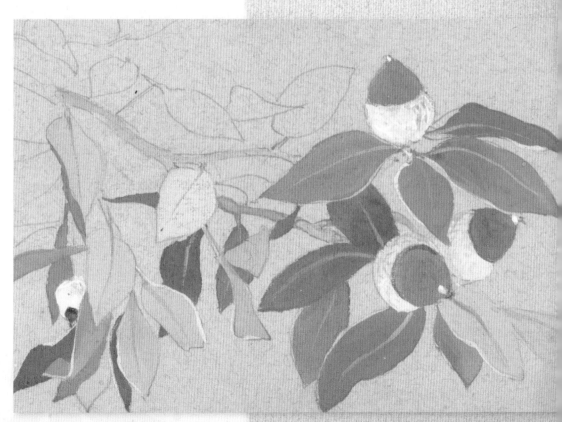

Children of Eternity

We are content to go on slowly with Him to whom a thousand years is one day! For we are "Les Enfants de L'eternite."

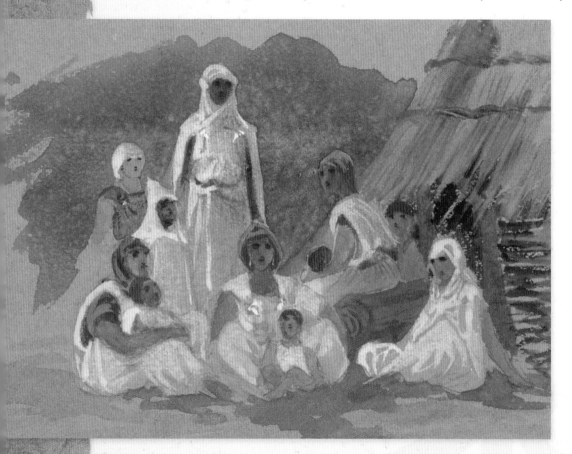

He has also set eternity
in the hearts of men;
yet they cannot fathom
what God has done from
beginning to end.

Ecclesiastes 3:11

He Who Inhabits Eternity

We have to do with One who "inhabiteth eternity" and works in its infinite leisure.

Some years ago, when a new railway cutting was made in East Norfolk, you could trace it through the next summer, winding like a blood-red river through the green fields. Poppy seeds that must have lain buried for generations had suddenly been upturned and had germinated by the thousand. The same thing happened a while back in the Canadian woods. A fir-forest was cut down, and the next spring the ground was covered with seedling oaks, though not an oak tree was in sight. Unnumbered years before there must have been a struggle between the two trees, in which the firs gained the day, but the acorns had kept safe their latent spark of life underground, and it broke out at the first chance.

And if we refuse to stay our faith upon results that we can see and measure, and fasten it on God, He may be able to keep wonderful surprises wrapt away in what looks now only waste and loss. What an up-springing there will be when heavenly light and air come to the world at last in the setting up of Christ's kingdom!

We live by faith, not by sight.

2 Corinthians 5:7

Endless Possibilities

The results need not end with our earthly days. Should Jesus tarry, our works will follow us. God may use, by reason of the wonderful solidarity of His Church, the things that He has wrought in us, for the blessing of souls unknown to us: as these twigs and leaves of bygone years, whose individuality is forgotten, pass on vitality still to the new-born wood-sorrel. God only knows the endless possibilities that lie folded in each one of us!

Then I heard a voice from heaven say,
"Write: Blessed are the dead who die in the Lord from now on."

"Yes," says the Spirit, "they will rest from their labor,
for their deeds will follow them."

Revelation 14:13

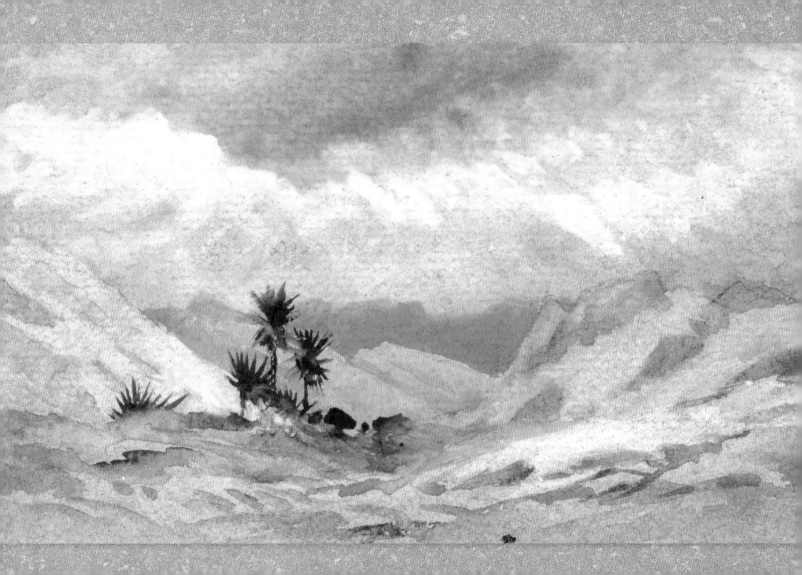

Who despises the day of small things?

Zechariah 4:10

Day of Small Things

Love

Other End of the Scale

Is not that equal in marvel to the other end of the scale of creation where we "lift up our eyes on high and behold who hath created these things, that bringeth out their host by numbers"? "He metes out the heaven with the span and comprehendeth the dust of the earth in a measure"—the great and the small again alike to Him. "Behold God is great. He maketh small the drops of water."

How childish it must seem to them, up in heaven, when we treasure the importance of a thing by its size. "Fulfilling His word" . . . "The meeting of His wishes"—that is all that matters.

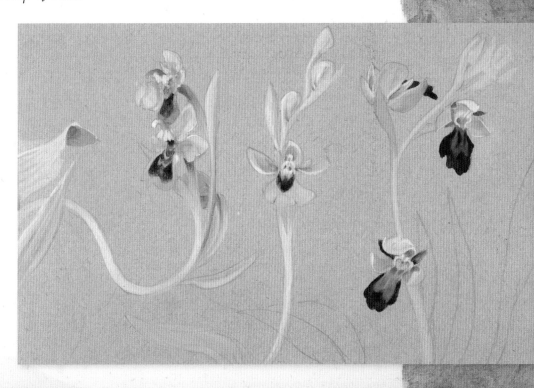

*W*ho is like the Lord our God,
the One who sits enthroned on high,
who stoops down to look
on the heavens and the earth?

Psalm 113:5–6

Crystallizing Point

My room ... at sunrise produces a camera
abscura of inverted cupolas that ring the
changes from rose through orange to straw color
against the background of the sky. It likewise
has the privilege of plastered walls—the
plaster made from the crushed crystals with
which the walls are built. You come upon them
in heaps, in glittering sandcolor, thrown up
alongside the gardens that they dig out of the
sand-drift. You can gather them by the armful.

These crystals have a word for us, too,
for each of them sprang out of some atom
of a growing point round which clustered
crystallized this endless beauty of form. If
we may but be a crystallizing point from
which God can work, it matters nothing how
insignificant that starting point.

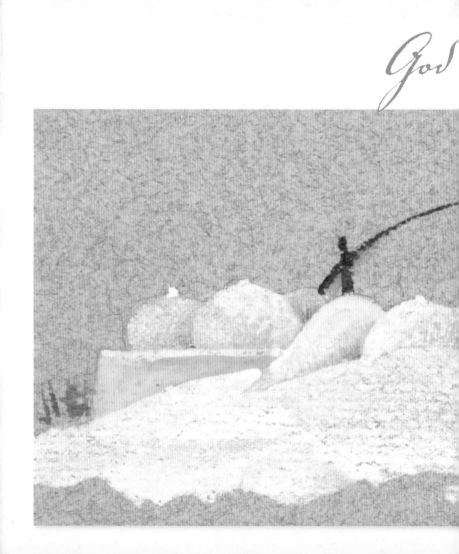

...alls things that are not as though they were.

Romans 4:17

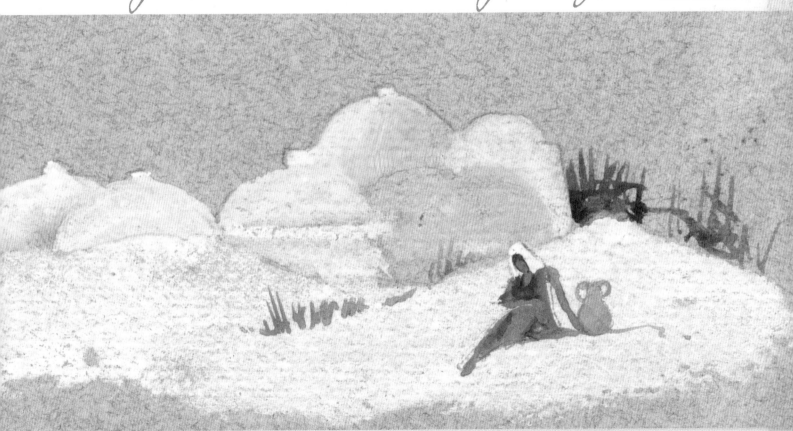

Cedars in the Making

If we hope for what we do not yet have, we wait for it patiently.

Romans 8:25

A little cedar branch was brought down from one of the mountain crests: dusky blue-green, with fawn-colored baby cones, so we thought, perched on it here and there. Suddenly these seeming cones began sifting down pale gold dust, and a touch released it in a thick shower. They were really catkins, and were opening and shedding pollen, and in three minutes the little box was half full. Visibly it contains nothing but impalpable lemon-colored powder.

Potentially it is a forest that would cover all our mountain crests along the countryside.

Less than nothing for God's cedar building, yet any and every invisible speck so charged with indwelling life that it can start a miracle working the moment that the wind has carried it to the appointed place.

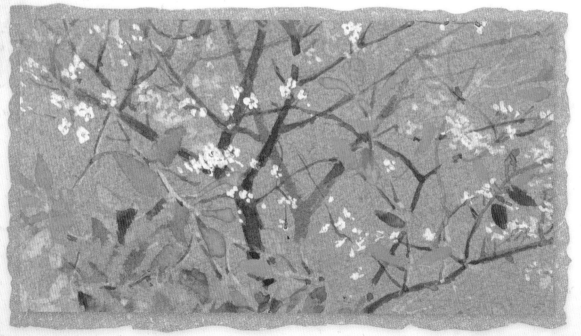

Pivots

The first impression of Palestine was of the strangely small scale of everything. But before nightfall one came to realize that this is an intrinsic part—that God wants to show us that nothing is great or small to Him who inhabited eternity in its dimensions of space as well as of time. It is a pivot land— and pivots are apt to be small things in the eyes of those who do not understand their meaning.

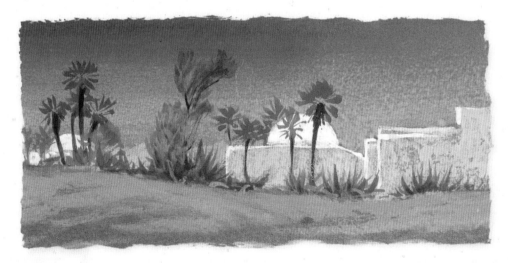

I know that you can do all things;
no plan of yours can be thwarted.

Job 42:2

Day of Small Things

*Such a day of small things still, but on God's terms,
and that is enough. Size as well as time and space
count nothing with Him.*

The foolishness of God is wiser
than man's wisdom, and the
weakness of God is stronger
than man's strength.

1 Corinthians 1:25

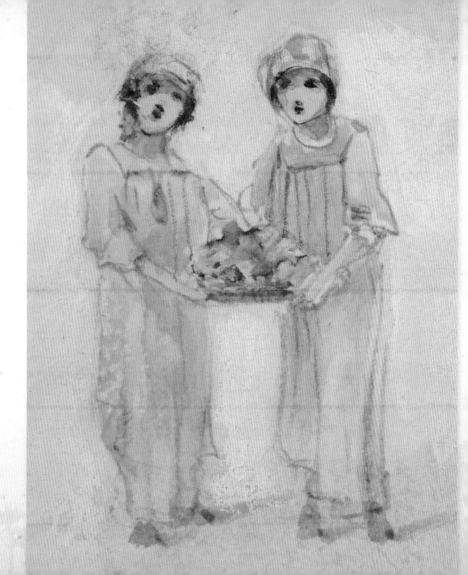

Glory in the Small

The glory of God in the infinitely small has been something new of late, and very blessed, for it throws a gleam of the fact that He can find that glory in the day of small things out here just as much as in the lands where souls crowd into His kingdom. The last, and I think most wonderful, glimpses of that glory of the tiny works came in a magazine yesterday which writes, "Sir Robert Ball says the microscope teaches us that there are animals so wonderfully minute that if a thousand of them were ranked abreast they could easily swing, without being thrown out of order, throughout the eye of the finest cambric needle ever made—yet each of the minute creatures is a highly organized number of particles, capable of moving about, of finding and devouring food, and of behaving in all respects as becomes an animal as distinguished from a fragment of unorganized matter."

And we pray . . . that you may live a life worthy of the Lord and may please him in every way: bearing fruit in every good work, growing in the knowledge of God.

Colossians 1:10

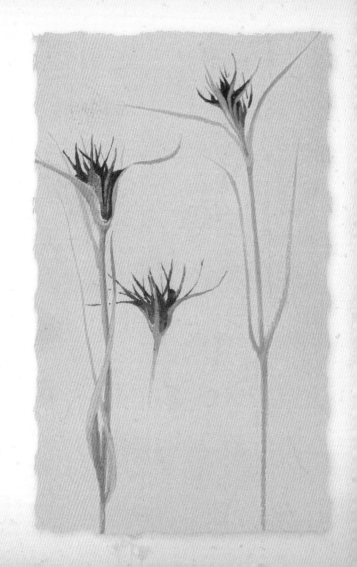

He tends His flock like a shepherd:
He gathers the lambs in his arms
and carries them close to his heart.

Isaiah 40:11

Shepherd of Our Souls

Love

Shepherd Heart

There was a pretty sight in the marketplace this morning—a procession of shepherds in from the desert, led off by ten or twelve little lads carrying the lambs in their arms. And the Lord with His Shepherd Heart will not set the souls down in a road too hard for them to follow—even if we under-shepherds make mistakes.

How the Good Shepherd follows the trail in all His endless patience. Even the torn wool on the briars helps Him on His way!

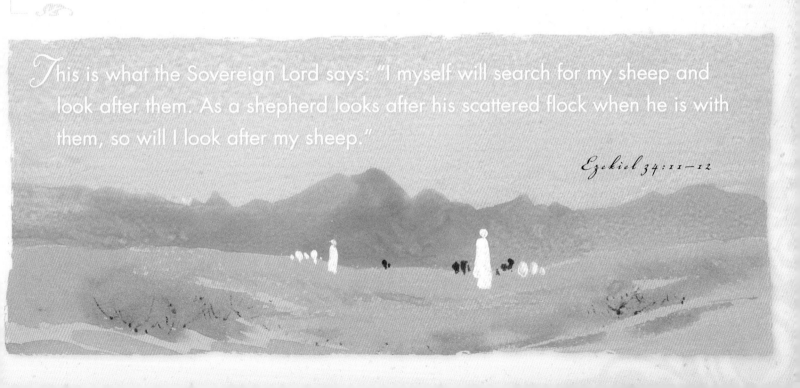

This is what the Sovereign Lord says: "I myself will search for my sheep and look after them. As a shepherd looks after his scattered flock when he is with them, so will I look after my sheep."

Ezekiel 34:11–12

Little Flock

There are side touches in translation of the Gospel of John that bring Him near. Yesterday "Fear not little flock" came in the chapter that we were working on and we were getting at the right word for "little flock."

 "Would that expression"—jelieb I think it was—"mean such a little flock that it would not be worth the Shepherd's care?" asked one.

 "No, if it is a very little flock the Shepherd cares for it all the more," answered Hadj Brahim.

Jesus said, "Do not be afraid, little flock, for your Father has been pleased to give you the kingdom."

Luke 12:32

August Oranges

All little miniature beginnings but all "beautiful in their time," like the dark green August oranges in the court below. The fact that they have got thus far into being is more than a promise. Like all the promises of God they are (given the conditions) an accomplishment begun. His "Yea" only waits our "Amen."

He has made everything beautiful in its time.

Ecclesiastes 3:11

Washing His Feet with Tears

"Until the day break and the shadows flee away, I will get me to the mountain of myrrh and to the hill of frankincense." That has been "the word of the Lord" this last day or two, with a meaning hitherto unseen. The gathering of the bitter-sweet myrrh of heartbrokenness over failure and shortcoming—over all the "might-have-beens" of the past—can bring one nearer heaven than the gathering of the frankincense of the hills, for the prayer needs for present and future. Such is His abounding grace, even where sin has abounded. The place where we wash His Feet with our tears has a great nearness to His Holy Place above.

The sacrifices of God are a broken spirit;
a broken and contrite heart,
O God, you will not despise.

Psalm 51:17

Ninety and Nine

In between writing I stop to scribble down the sunset that is going on, as well as the jogging train will allow—our last bit of northern winter with all its depths of meaning. It is strange to think of being among blue skies and roses and jessamine [jasmine] the day after tomorrow. But one gets more of the breath of spring through the little half-asleep January buds than through all the wealth of beauty down south. It is something like that with the feebly breaking life in those hearts out there in the darkness. There is a joy over it deeper even than in the summer-tide of the spiritual atmosphere in England. Is it not so that as the Lord looks down on the earth, He sees the slowly swelling buds of His dawning springtime here and is glad. "He rejoiceth more of that sheep than of the ninety and nine that went not astray."

Jesus said, "Your Father in heaven is not willing that any of these little ones should be lost."

Matthew 18:14

Nothing Irretrievable with God

Our last new helper up here is—Almed! He had never entered our heads till a few days ago, when Blanche bethought her that it might give him one more chance of getting on his feet. He was touched and softened over his sister's death, and he was looking so ill that we thought he would not be long after her. Fresh air and food have already ended that and he is intensely happy at being here. "If she had bought this place for no other reason than to give me the earth to walk on, it would have been worthwhile," he said. Wreck as he is, there is something touching about him—something of possibilities yet undestroyed. "There is nothing irretrievable with God," as Thomas Erskine said.

The Lord says, "If you repent, I will restore you that you may serve me."

Jeremiah 15:19

Lost Lamb

I must put down a dear little story told me by a friend this morning. Her small niece, aged somewhere between three and four, was heard telling the parable of the lost sheep to a cousin a year or two older. The finale was, "So the Shepherd put back the lamb into the fold, and then He mended up the hole where it had got out." All of sanctification as well as salvation lay in the wisdom of those child-lips!

"I myself will tend my sheep and have them lie down," declares the Sovereign Lord. "I will search for the lost and bring back the strays. I will bind up the injured and strengthen the weak . . . I will shepherd the flock with justice."

Ezekiel 34:15–16

We love because he first loved us.

1 John 4:19

Vocation of Loving

The True Light

How the angels must watch the first day when that light reaches a new spot on this earth that God so loves—and the great wall of darkness is pushed back one tiny bit—and, oh, the joy of being allowed to go with His message that first day. How can His people hold back from that joy while one corner remains unvisited by the Dayspring!

Jesus said, "I am the light of the world. Whoever follows me will never walk in darkness, but will have the light of life."

John 8:12

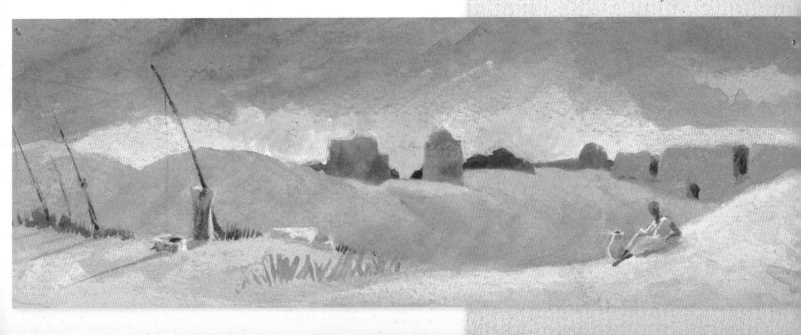

Saved to Save

We ourselves are "saved to save"—we are made to give—to let everything go if only we may have more to give. The pebble takes in all the rays of light that fall on it, but the diamond flashes them out again: every little facet is a means, not simply of drinking more, but of giving more out. The unearthly loveliness of the opal arises from the same process carried on within the stone: the microscope shows it to be shattered through and through with numberless fissures that catch and refract and radiate every ray that they can seize.

Jesus said,

"It is more blessed to give than to receive."

Acts 20:35

Jesus said, "I tell you the truth, whatever you did for one of the least of these brothers of mine, you did for me."

Matthew 25:40

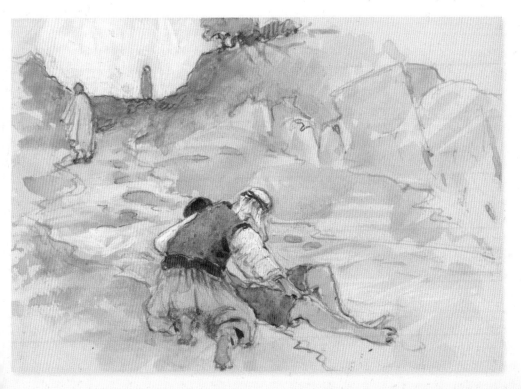

Vocation of Loving

I have been thinking lately what a work for God it is, just loving people. He says in Deuteronomy 22, "If an ox or an ass has gone astray, thou shalt bring it unto thine own house, and it shall be with thee till thy brother seek after it." I think He gives us sometimes a like service for souls—wandering souls that we cannot bring back to Him. Sometimes all we can do is to keep them near us, and show the kindness of God to them, and hold them in faith and prayer till He comes to seek them.

Parable of the Stream

"Out of him shall flow" comes afresh these days, brought
home by a landlocked backwater in the little river here
that only lets its stream filter slowly through a bank of
stones instead of running free. The still pool of living
water lies in every saved soul, keeping life within that
little plot of ground, but there is a world of difference
between a pool and a river. A river is wide open to its
source, and as wide open to the needs lower down. We
need all barriers down—manward as well as Godward—
to believe for the outflowing as definitely as the inflowing.

Jesus answered, "Everyone who drinks this water will
be thirsty again, but whoever drinks the water I
give him will never thirst. Indeed, the water I give
him will become in him a spring of water welling
up to eternal life."

John 4:13–14

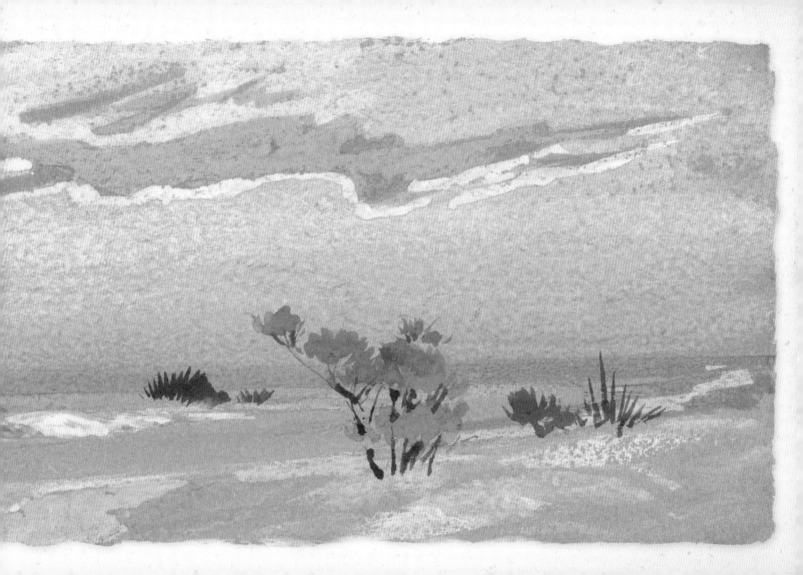

Be imitators of God, therefore, as dearly loved children and live a life of love, just as Christ loved us and gave himself up for us as a fragrant offering and sacrifice to God.

Ephesians 5:1–2

Desert Longing

I don't think anything has ever been quite like that joy of getting back to one of these desert villages—to be having for three weeks anyway the longing of my heart: to be living in a real native house of their own building, so down on their level that they come in and out promiscuously—now a couple of women in their thick woolen plaits, now a troop of girlies in all colors of the rainbow, now a set of boys sitting as still as can be. For the first time this evening we go out for a turn, after sunset, just along the lane leading out of the town in the place where you can see the irregular line of palms against the dead blue of the eastern sky, the "old gold" of walls and sand still clutching the western sky and the dark brown silhouette of a camel here and there. Oh how I love it!

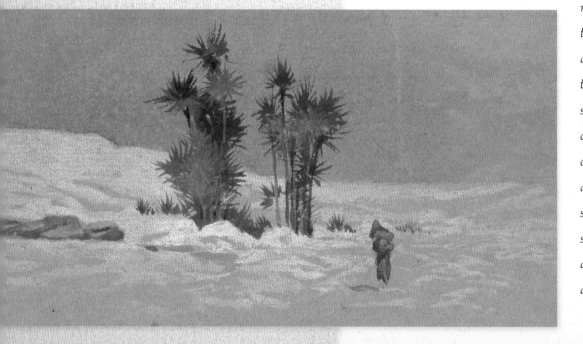

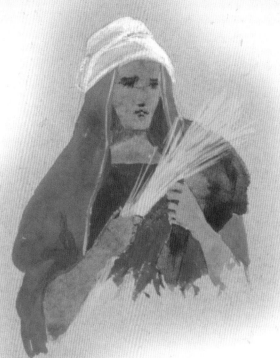

Alongside the People

This morning these words came with power:
"Whatsoever is born of God overcometh
the world." I feel so that the desire
that only grows the stronger as it
remains unmet—to get down and
down alongside the people and live
a life on more "apostolic" lines—must
be of God. If so it must find its way too.
If we could anyhow—anywhere—live
more as Jesus lived His last years!

The Word became flesh and made his dwelling among us.

John 1:14

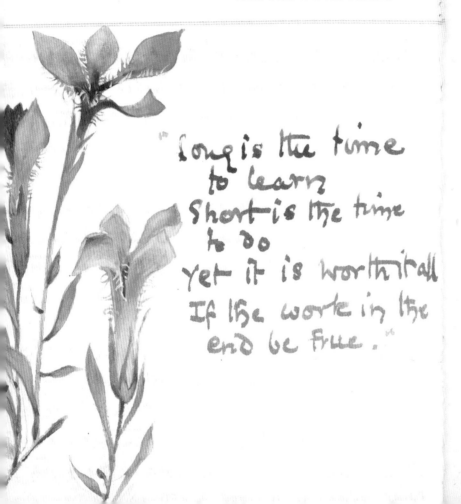

SUNDAY, OCTOBER 1.

18TH SUNDAY AFTER TRINITY.

"Long is the time
to learn
Short is the time
to do
Yet it is worth it all
If the work in the
end be true."

If the Work Be True

The last few gentians are out—the fringed one, with a smell like cowslips. Their leaves are turning yellow by the time they flower, like souls called out at the eleventh hour.

"Long is the time to learn
Short is the time to do,
Yet it is worth it all
If the work in the end be true."

Jesus said, "As long as it is day, we must do the work of him who sent me. Night is coming, when no one can work."

John 9:4

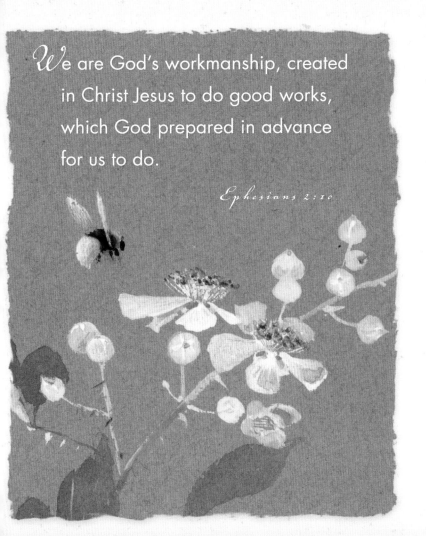

We are God's workmanship, created in Christ Jesus to do good works, which God prepared in advance for us to do.

Ephesians 2:10

Parable of the Desultory Bee

A bee comforted me very much this morning concerning the desultoriness that troubles me in our work. There seems so infinitely much to be done, that nothing gets done thoroughly. If work were more concentrated, as it must be in educational or medical missions, there would be less of this—but we seem only to touch souls and leave them. And that was what the bee was doing, figuratively speaking. He was hovering among some blackberry sprays, just touching the flowers here and there in a very tentative way, yet all unconsciously, life—life—life was left behind at every touch, as the miracle-working pollen grains were transferred to the place where they could set the unseen spring working. We have only to see to it that we are surcharged, like the bees, with potential life. It is God and His eternity that will do the work. Yet He needs His wandering, desultory bees!

Reproducing Eternally

"Threescore years and ten" close tonight—with more thoughts than will easily get transferred to paper. The word that has been uppermost these last days is: "Let Thine heart keep my commandments—for length of days and years of life and peace shall they add unto Thee." For in obedience to the Spirit, any and every day of those that are left may carry seeds of eternal life that will go on working—reproducing eternally.

Do not forget my teaching,
but keep my commands in your heart,
for they will prolong your life many years
and bring you prosperity.

Proverbs 3:1

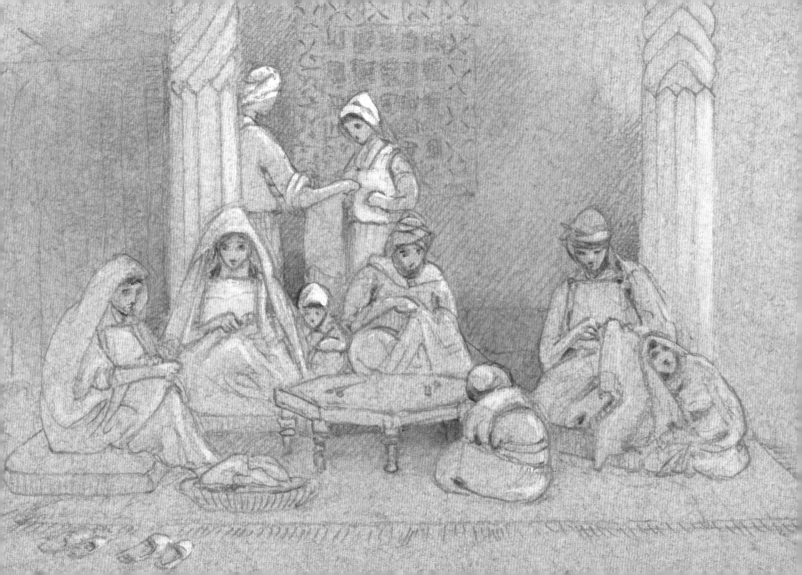

GLOSSARY

In Order of Appearance

Ferpeck (The Unveiled Face of Jesus): *A major glacier and view enjoyed by Lilias during an alpine vacation in Switzerland.*

Dent Blanch (The Unveiled Face of Jesus): *A mountain in alpine Switzerland.*

Melha (Look at Jesus): *An Arab toddler, daughter of Fata bent Fatima, part of their Algiers "extended family."*

snowdrop (Autumn Crocus): *A bulbous plant, native to Eurasia, having nodding white flowers that bloom in the early spring.*

cyclamen (The First Cyclamen): *A plant bearing showy white, pink, or red flowers and, normally, deep green foliage.*

soldanella (Glimmer of Light; Glory of the Impossible): *A delicate alpine flower with two or three tiny violet flowers on each stem.*

Noria (Noria in the Garden): *An elevated decorative structure of a garden well.*

godet (Noria in the Garden): *One of many iron cups on a wheel that dips deep into the underground well.*

Keswick (Catching His Thought): *The town in the Lake District of England which housed the permanent Keswick Convention, a "spiritual clinic" that eventually parented similar programs by the same name throughout the world. The first conference in Broadlands played a significant role in Lilias's life, and the Keswick Conventions continued to be an event to which she returned for refreshment through the years and to recruit workers for North Africa.*

Tolga (Standing in Spirit): *A primitive desert village especially dear to Lilias for the fraternity of the Sufi Brotherhood (Muslim Mystics) there who took her into their lives and hearts.*

Souf (Standing in Spirit): *Oued Souf, a cluster of village oases of the El-Oeud. This was two hundred miles into the Sahara desert, which was a six-day march by horse-drawn trap and camel in Lilias's early journeys.*

Touzer (Standing in Spirit; Hills of Touzer): *An oasis of the El Djerid, a Tunesian district in the Southlands, especially dear to Lilias.*

Pisa Cathedral (The Vault of Heaven): *Cathedral in the capital city of Pisa, central Italy, in the region of Tuscany—known for its "leaning tower."*

Ali (The Lord's Prayer): *A young man from Touzer who, along with his brother Amar, came to Algiers to be trained for a future ministry to his own people in the Southlands.*

Matterhorn (Light Chasing Darkness; They That Wait): *An alpine mountain in the southwestern region of Switzerland.*

Obere Gabelhorn (Light Chasing Darkness): *An alpine mountain of Switzerland.*

celandines (February Flowers; Pure and Sweet): *A plant native to Eurasia having deeply divided leaves and yellow flowers.*

Blida (Bell of Blida; Parable of Lost Blessing; Low Enough): *A small mountain village thirty-five miles south of Algiers where Lilias established her first mission station outside of the city.*

Touaregs (Riverbed): *Masked camel riders who dominated the mountainous core of the deep Sahara.*

Daily Light (In the Way of His Steps): *A small volume of daily Scripture verses, with both morning and evening selections, compiled by Samuel Bagster of London, England, in 1794—a daily companion for Lilias!*

"attrait" (Focused Life; Alone with God): *This particular use of the French word for "attraction" is seemingly unique to Lilias.*

Pescade (Lesson of the Crab): *A coastal town outside of Algiers.*

(Continued)

GLOSSARY

(Continued)

Bounab (Parable of the Choked Well): *Name of a well in a desert oasis near Nefta in Tunisia.*

Aissha (Pure and Sweet): *A common Arab name, referring in this instance to a young woman from the nearby village of Blida.*

Fehira (A Quiet Heart): *An Arab woman from Algiers, a convert to Christianity.*

Tolga hen (Place of Sacrifice): *A hen given to Blanche Haworth, Lilias's colleague, by an Arab woman during a visit to Tolga.*

Breitenboden Valley (Water of Life): *A valley in the Swiss Alps.*

trolleys (Parable of the Trolleys): *Carts suspended from a pulley, used for transporting granite from the quarries in West Yorkshire, England.*

fondouk (Weak with Him): *Name for the primitive inn in Touzer in the Southlands of Algeria.*

the shore (Wild Lilies): *The shore of the Mediterranean Sea.*

Taberkatchent Valley (Mountains of Difficulty): *Mountainous area of the Atlas Range, south of Algiers.*

their watchword (The Divine Exchange): *"Their" refers to the mission workers of Blida who had been challenged with problems concerning the Blida well—critical to the establishment of their mission outpost and the trigger for Lilias's reflection on water.*

Mischabel (Waiting on God): *An alpine mountain in Switzerland.*

Findeln (Waiting on God): *An alpine village in Switzerland where Lilias enjoyed a period of rest.*

Fortification Woods (Fortification Woods): *A secluded area, a five-minute walk from Lilias's first flat in the French area of Algiers.*

due south (Desert Teaching): *From Constantine, a chief fortress city situated on an isolated block of rocks 288 miles southeast of Algiers—the departure point for the journey straight south across the tablelands toward the Southlands of the Sahara desert.*

El Kantara (Desert Teaching): *A gorge in the Aures Mountain chain, 150 miles south of Constantine—opening into the Sahara desert, it is referred to as the "the gate of the desert."*

Breithorn (They That Wait): *A mountain in Switzerland.*

East Norfolk (He Who Inhabits Eternity): *A region in East Anglia, located in the southeast of England.*

pivots (Pivots): *By her use of the noun "pivot" (for pivotal), I believe Lilias meant to emphasize the tiny point upon which so much turned or started. She elaborates on this thought in the extended section from which this is taken.*

Hadj Brahim (Little Flock): *A young Arab man who helped the Revision Committee in Algiers translate the Gospel of Luke into a dialect more accessible to Algerians.*

Almed (Nothing Irretrievable with God): *An Arab man from Algiers who Lilias and her workers took under their care after his sister died a Christian death.*

Blanche (Nothing Irretrievable with God): *Blanche Haworth, an English colleague of Lilias, one of the original trio to go to Algeria.*

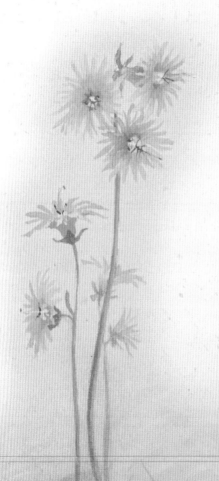

REFERENCES

Light

The Radiance of Christ

The Unveiled Face of Jesus – 13 August 1899

The Morning Star – 17 January 1899

Shaft of Light – 4 June 1906

Turn Your Eyes Upon Jesus – Focussed: A Story and a Song (pp. 1–2)

Look at Jesus – 28 July 1909

The Baby Moon – 11 February 1899

Soul Vision – The Way of the Seven-fold Secret (p. 26)

Dawn – 31 December 1907

When the Day Breaks – 14 August 1926

Faith

Autumn Crocus – 3 October 1925

The First Cyclamen – 23 September 1906

Clouds – 10 July 1896

Trained Faith – 9 September 1902

Faith with a Spring – 10 July 1896

Believe! – 1 August 1901

Sails to the Wind – 22 August 1902

Glimmer of Light – 17 March 1904

Stretched-Out Hand – 17 December 1899 and 1 January 1900

The Blissful God – 29 September 1904

Deep Waters – 20 December 1927

Prayer

Noria in the Garden – 26 July 1906

Praying Downwards – 21 and 22 March 1926

Catching His Thought – 31 July 1913

Standing in Spirit – 26 March 1904

Vibrations – Vibrations (pp. 4–5), adapted from Journal entry for 30 January 1896

Fire Upwards! – A Challenge to Faith (p. 12)

Is Jesus Not Enough? – 23 May 1904

Giving Our Amen – 19 September 1908

The Vault of Heaven – 9 August 1914

The Lord's Prayer – 23 December 1925

Holy Spirit

Minding of the Spirit – 7 May 1889

Smoldering – 29 August 1899

Weight of Glory – 30 July 1895

Give Us Fire – 8 September 1917

A River Lesson – 8 August 1899

Sweet Grace from Above – A Thirsty Land (p. 12)

Guidance

God's Guidance – 30 September 1903

Mountain Lesson – 13 August 1899

A Swifter Path – 25 April 1917

God's Initiation – 22 January 1928

Quiet Certainty – 29 April and 11 November 1927

God's Primer

Hide and Seek – 28 October 1896

Light Chasing Darkness – 12 August 1901

February Flowers – 13 February 1927

Harbinger of Spring – 24 January 1927

Wave Offering – 25 August 1901

Harvest Time – 15 June 1916

Bell of Blida – 6 January 1911

Olive Trees – 18 September 1912

Hills of Touzer – 21 March 1914

Riverbed – 3 April 1893

(Continued)

REFERENCES

Life

Gateway to Life

Act or Process? – Parables of the Cross (p. 12)

Joined at the Heart – July 1897

Parable of the Acorn – 6 October 1895

Parable of the Well Water – 15 June 1909

Stages of Heavenly Growth – Parables of the Cross (pp. 22–23)

The Glory of His Gladness – Parables of the Cross (pp. 34–35)

Growing Points – 23 December 1900

Life in Christ

Rivers of Living Water – 8 August 1899

In the Way of His Steps – 8 September 1896

Parable of the Lost Blessing – 14 May 1903

Grand Simplicity – A Ripened Life (pp. 7–8)

Focused Life – Focussed: A Story and a Song (pp. 8–9). This devotional thought was inspired by an insight from God's creation, which Lilias later published in a leaflet titled Focussed. This meditation took on new life when Mrs. Helen Lemmel, inspired by the challenge of this leaflet to "turn full your soul's vision to Jesus, and look and look at Him," wrote the hymn, "Turn Your Eyes Upon Jesus," which later became the theme of the 1924 Keswick Convention—a song beloved to this day.

Lesson of the Crab – Travel Journal, 1893 (p. 18)

Parable of the Choked Well – 6 March 1895

Goal of Maturity – Parables of the Cross (p. 14)

Grand Independence of Soul

His Ideal Unhindered – Parables of the Cross (pp. 14–15)

Pure and Sweet – 21 February 1906

A Quiet Heart – 5 April 1898

(Continued)

REFERENCES

Love

The Poetry of God's Ways

Wings of the Morning – 2 May 1914

Closed Window, Open Door – 6 May 1904

Not Bound to Repeat – The Glory of the Impossible (*p. 7*)

Thy Will Be Done – 23 January 1916

The Rest of His Steps – 7 March 1915

The Tracing of God's Way – 18 January 1927. This was written when Lilias was confined to her bed and her room.

Alone with God

Waiting on God – 29 August 1901

Daisies Talking – 6 April 1899, Egerton Journal

Fortification Woods – 7 May 1889, Sketchbook

Simple Beholding – 19 August 1901, Sketchbook

Desert Teaching – 3 April 1900 and 6 March 1895, Journal

Alone with God – 16 August 1900

A Bit of Quiet – 3 March 1895, Journal

Refuge – 13 March 1896, Egerton Journal

God's Time

They That Wait – Journal, 1896 (*pp. 45–48*)

God of Eternity – 12 December 1920

God's Delays – 29 December 1903

Children of Eternity – 1 March 1921

He Who Inhabits Eternity – Parables of the Christ-Life (*pp. 46–47*)

Endless Possibilities – Parables of the Cross (*pp. 35–36*)

Day of Small Things

Other End of the Scale – 24 October 1920
Crystallizing Point – 8 November 1927
Cedars in the Making – AMB Story of 1924–25 (p. 3)
Pivots – 26 March 1924
Day of Small Things – 1 January 1902
Glory in the Small – 24 October 1920

Shepherd of Our Souls

Shepherd Heart – 4 March 1917
Little Flock – 29 March 1908
August Oranges – 11 August 1906
Washing His Feet with Tears – 14 March 1926
Ninety and Nine – 18 January 1896
Nothing Irretrievable with God – 23 July 1906
Lost Lamb – 28 May 1926

Vocation of Loving

The True Light – March 1895
Saved to Save – Parables of the Cross (p. 18)
Vocation of Loving – 25 April 1891
Parable of the Stream – 3 August 1895
Desert Longing – 16 April 1900
Alongside the People – 5 January 1904
If the Work Be True – 1 October 1899
Parable of the Desultory Bee – 9 July 1907
Reproducing Eternally – 13 July 1923 (on the eve of her birthday)

BIBLIOGRAPHY

The Written Legacy of I. Lilias Trotter

Books by I. Lilias Trotter

*Between the Desert and the Sea**
The Master of the Impossible
Parables of the Christ-Life
Parables of the Cross
The Way of the Seven-fold Secret

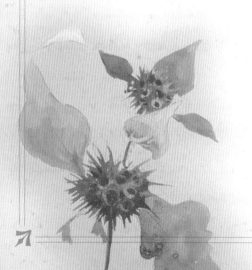

Booklets by I. Lilias Trotter

Back-ground and Fore-ground
A Challenge to Faith
Cherry Blossom
Focussed: A Story and a Song
The Glory of the Impossible
Heavenly Light on the Daily Path
A Life on Fire
Literature for Moslem Boys
A Ripened Life
Sand Lilies
Smouldering
A South Land
A Thirsty Land and God's Channels
Trained to Rule
Vibrations
Winter Buds

Story Parables by I. Lilias Trotter

The Bag of Wool
The Bedouin and His Camel
The Blood Feud of El Hanouchi
The Debt of Ali Ben Omar
The Field of Sahab en Niya
Landsnakes and Seasnakes
The Letter that Came from a Far Country
The Lost Ones in the Sahara
Neseefa the Slave Girl
The Robe of Er-Rashid
The Story of the Nightingale
Water Lilies: A Paper for Mothers

Books about I. Lilias Trotter

Elisabeth Elliot. *A Path Through Suffering*. Meditations based on Trotter's *Parables of the Cross* and *Parables of the Christ-Life*. Ann Arbor: Vine Books, 1992 (in print).

Constance E. Padwick. *I. Lilias Trotter*. Crydon: Watson, n.d.

Blanche A. F. Pigott. *I. Lilias Trotter*. London: Marshall, 1929.

Miriam Huffman Rockness. *A Passion for the Impossible: The Life of Lilas Trotter*. Grand Rapids: Discovery House Publishers, 2003 (in print).

I. R. Govan Stewart. *The Love That Was Stronger*. London: Lutterworth Press, 1958.

Patricia St. John. *Until the Day Breaks*. Bromley, Kent: OM Publishing, 1990.

Other

AMB Story of 1924–25
Diaries and Journals of I. Lilias Trotter

All works, unless otherwise noted, are out of print. Copies of these works are housed at the Trotter Archives at the Arab World Ministries United Kingdom Headquarters in Loughborough, England.

And the blossoming continues...

In Algeria today there are many Christians who thank God for the witness, prayer, perseverance, and faithfulness shown by Lilias Trotter and her co-workers a century ago. Churches are now blossoming, new challenges and difficulties are being faced, and Algerian believers are maturing in their faith.

In 1964 the Algiers Mission Band merged with what is now Arab World Ministries. To receive information on how to pray for and support Christians in the Arab world—including Algeria—please contact Arab World Ministries at one of the addresses below, or visit the website www.awm.org.

UK: AWM, PO Box 51, Loughborough, Leicestershire, LE11 0ZQ, UK
E-mail awmuk@awm.org

USA: AWM, PO Box 96, Upper Darby, PA 19082, USA
E-mail awmusa@awm.org

Canada: AWM, PO Box 3398, Cambridge, Ontario, N3H 4T3, Canada
E-mail info@awmcanada.org

The Netherlands: AWZ, Postbus 57, 1619 ZH Andijk, The Netherlands
E-mail awz@a2bmail.net

France: MENA, BP 317, 26003 VALENCE CEDEX, France
E-mail bureau@mena-france.org